From Sketch to Painting

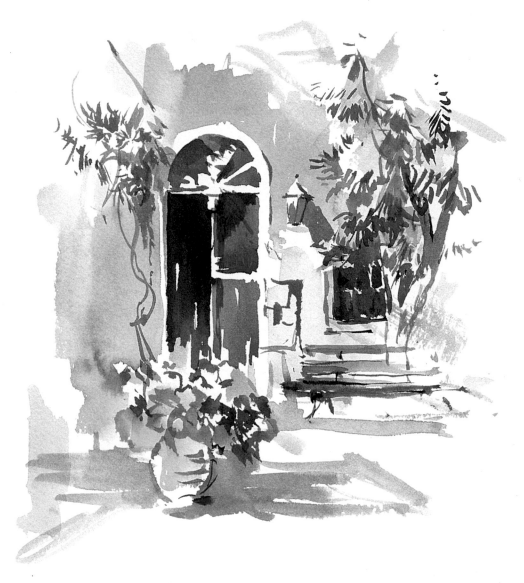

To my sisters, Mary and Leonie,
for being such good lifelong friends.

From Sketch to Painting

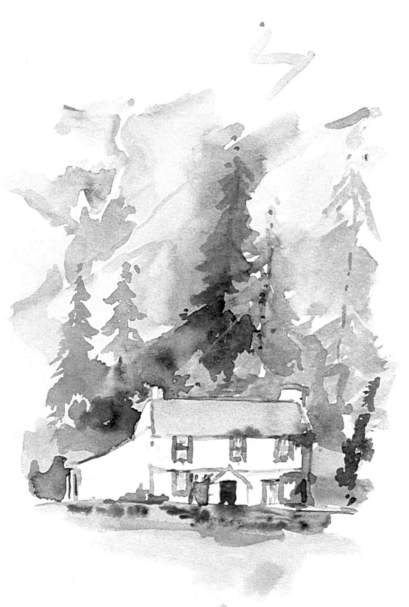

SEARCH PRESS

First published in Great Britain 2003

Search Press Limited
Wellwood, North Farm Road,
Tunbridge Wells, Kent TN2 3DR

ISBN 0 85532 995 5

The Publishers and author can accept no responsibility for
any consequences arising from the information, advice or
instructions given in this publication.

The publishers would like to thank Winsor & Newton for
supplying some of the materials used in this book.

Suppliers
If you have difficulty in obtaining any of the materials and
equipment mentioned in this book, please visit the Search
Press website for details of suppliers: www.searchpress.com

Alternatively, you can write to the Publishers at the address
above, for a current list of stockists, which includes firms
who operate a mail-order service, or you can write to Winsor
& Newton requesting a list of distributers.

Winsor & Newton, UK Marketing
Whitefriars Avenue, Harrow, Middlesex HA3 5RH

Publishers' note
All the step-by-step photographs in this book feature
the author, Wendy Jelbert, demonstrating how to
develop paintings from sketches. No models have
been used.

Page 1
Courtyard
Sketchbook size: 150 x 200mm (6 x 8in)
*This watercolour sketch shows how simple shapes can be built up
to form a rather complicated picture.*

Pages 2–3
White cottage, Lake Windermere
Sketchbook size: 230 x 305mm (9 x 12in)
*A burnt sienna water-soluble pencil sketch from my sketchbook
with a watercolour study of the cottage.*

Opposite
The effect of counterchange
Sketchbook size: 150 x 200mm (6 x 8in)
*The top sketch, worked in watercolours, is a demonstration piece
that shows how the use of dark background colour brings lighter
objects forward. The lower sketch, on the other hand, shows how a
light background emphasizes the strength of the foreground
colours. This sketch is also an example of how you can use water-
soluble pencils as a dry medium.*

Printed in Spain by A. G. Elkar S. Coop. 48180 Loiu (Bizkaia)

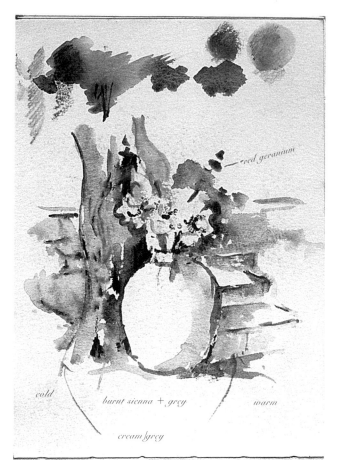

red geranium

cold — *burnt sienna + grey* — *warm*

cream/grey

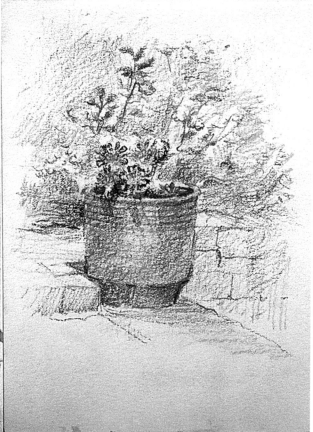

Contents

Introduction

What better than to be able to record precious holiday memories, a
bustling market, shadows falling across a favourite building, textured
foliage, buildings and much more in a sketchbook. This is what most
artists enjoy – the gathering together of information that can be used
in many different ways in future paintings. There are no hard and fast
rules about what medium should be used when sketching, or how a
subject should be approached, and this allows a freedom which is
both exciting and invigorating. To be able to open a sketchbook and
capture images, thoughts, colours and textures, using whatever
medium you have to hand, is wonderfully liberating.

Quite naturally, novice painters often give up the idea of keeping a
sketchbook without even trying to capture what they see, because
they are not sure how to begin. It is more simple than they think and
those who are keen enough to start often find that they are
developing their own way of working, and in the process they are
creating a book that is as individual and original as a personal journal.
If they persevere, it does not take them too long to discover that
sketching is simple, and it is not too hard to capture whatever
inspires them.

In this book I give key pointers on how to observe and what to
look out for. I talk about all the ingredients that make sketching
rewarding and successful, with demonstrations and tips showing how
they can be developed into beautiful paintings. The secret is to sketch
what inspires you, to record useful details and to absorb them into a
finished composition you can be proud of. Above all,
you should relax and have fun!

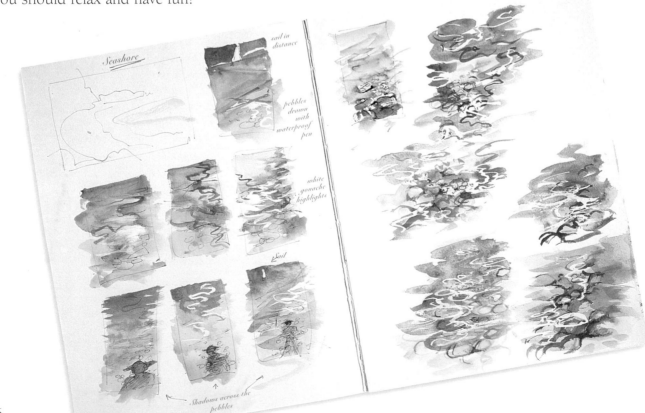

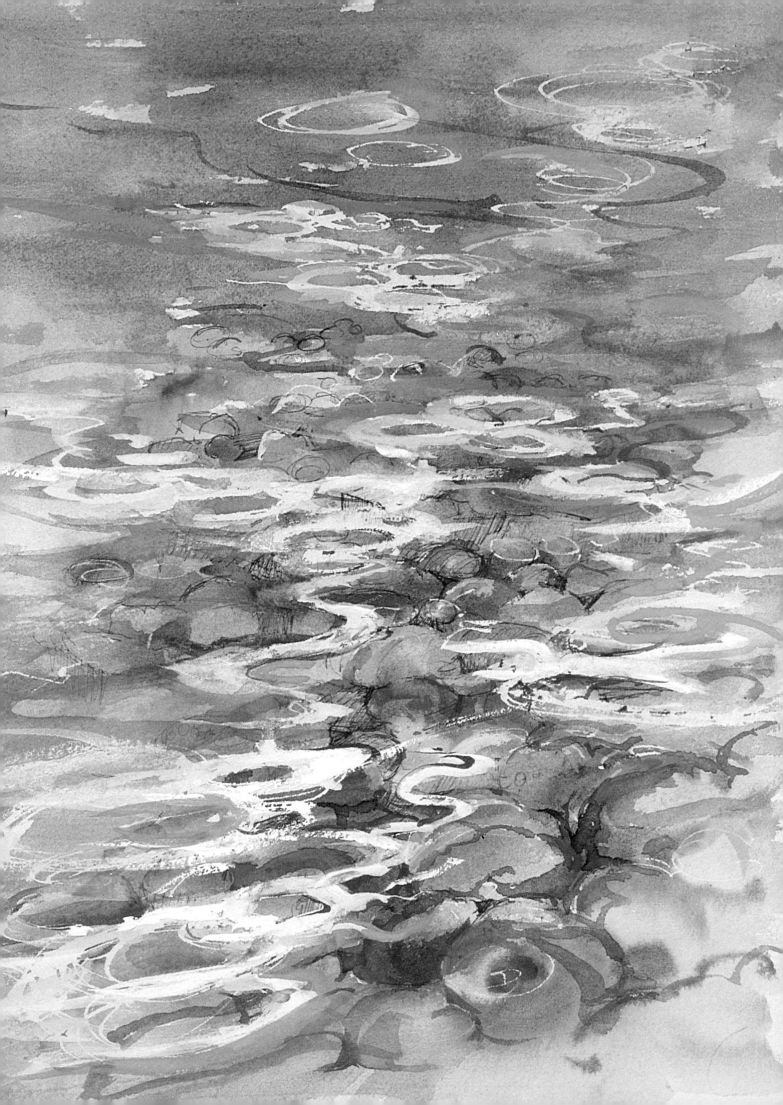

Materials

I sketch mostly when I am out and about and keep my materials lightweight and simple, cutting down on equipment where possible. If you are just starting to sketch, you should have a trial run before you venture out for the first time. Sometimes the materials you want to take just will not fit in your bag, and decisions have to be made about what to leave behind. There is only one rule: keep everything simple!

SKETCHBOOKS

There are many different sketchbooks to be found and it can be a bewildering choice for anyone just starting to sketch. They vary in binding, size, shape and the type and colour of paper they contain. Some have paper with a smooth surface and they are ideal for pencil techniques and pen and ink, others contain heavier watercolour paper and these can be used for quick watercolour sketches or even small paintings. Most sketchbooks hold only one type of paper, although the colours may vary. Some are spiral-bound, which facilitates drawing and sketching because the papers lie flat and do not spring up when you are working. It is worth finding out what you feel comfortable with and important to use the right media with the right paper.

I like to use hardback books 250 x 175mm (10 x 7in), but I also use smaller books 125 x 175mm (5 x 7in) that will fit into a pocket or a bag easily. The latter are very useful because I can carry them around with me wherever I go. I prefer to use 190gsm (90lb) watercolour paper sketchbooks, but I also have several books containing thick cartridge paper. These can be used for both drawing and painting. I also like gummed pads which are available in different weights and a wide range of sizes. I often carry small pieces of 190gsm (90lb) watercolour paper with me, plus a lightweight cartridge paper sketchbook. If I am lucky enough to find something I want to record, I can quickly sketch it and secure it inside my sketchbook.

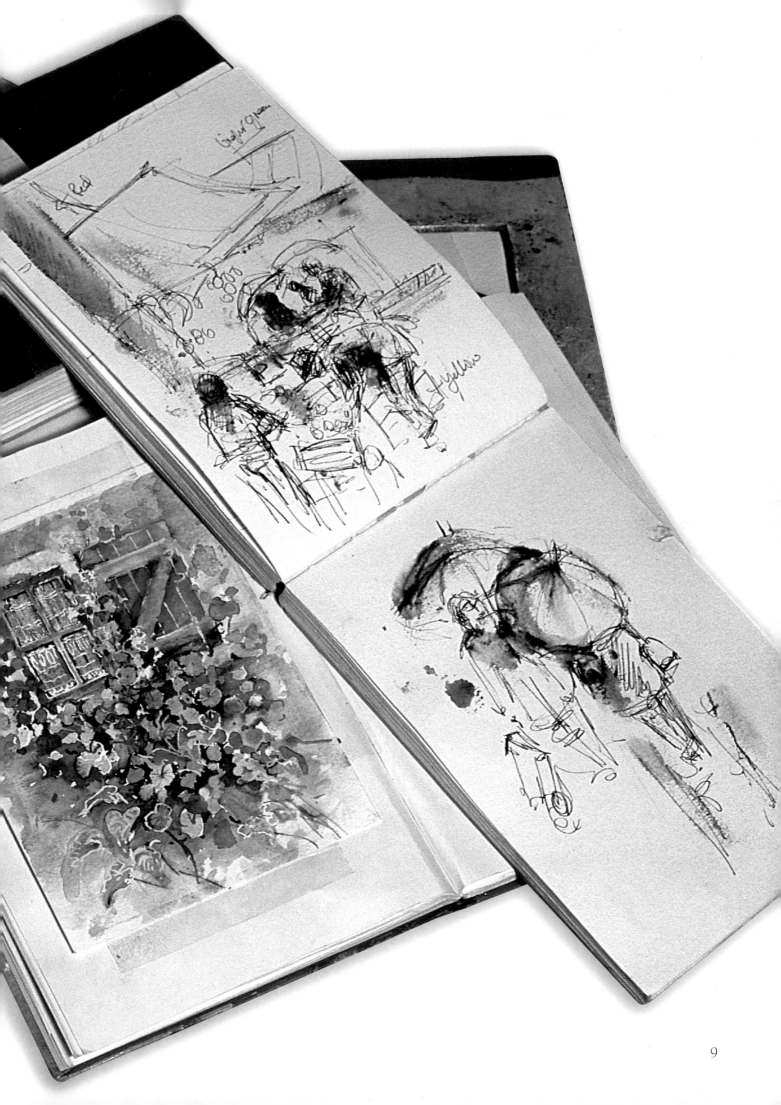

Pencil sharpener

Water-soluble pencils

Water-soluble graphite pencils

Felt-tipped pens

Putty eraser

Waterproof steel-nibbed pens

Brush pen

Water-soluble art pen

Graphite pencils

Craft knife/scalpel

Ballpoint pens

Water brush

PENCILS AND PENS

There are many different pencils and pens available and I use a wide variety of them. That's the beauty of sketching – you can capture a scene or image quickly with whatever you have with you. Make sure that pencils are always well sharpened and that pens are clean, and keep them together. I store mine carefully in a large, transparent zipped pencil case.

Water-soluble pencils

These are available in a good range of colours and they can be used wet or dry. They are excellent for making colour notes which can be used as reference back in the studio. Prices vary – you usually pay for what you get and it is worth buying better quality pencils if you can. I prefer the 'fatter' ones which have more pigment and flow better. Washes are easily achieved by extracting the colour from the pencil tip with a brush and water, or they can be used to enhance watercolour washes. When going sketching, I take just a few specially chosen colours rather than a whole set which can be quite heavy.

Felt-tipped pens

These are available in different sizes and varieties and they are great for making quick, bold sketches. You can buy both water-soluble and waterproof felt-tipped pens. The former can be diffused with water to create beautiful wash effects; the latter are great for detail and precise drawings.

Waterproof steel-nibbed pens

These are available in black, sepia and a range of nib sizes. I find 02 and 03 are the best size when sketching. They are ideal for a main drawing, or for pen, line and wash techniques, especially if the image needs to stay intact.

Ballpoint Pens

I use these frequently for quick spontaneous sketching and although they are limited in nib-width and colour, they are good for precise work and reference doodles.

Pencil sharpener

I carry one of these all the time, but it must be renewed quite often as it blunts quite quickly.

Craft knife/Scalpel

I use a scalpel for sharpening pencils in my studio. Keep the sheath on the blade when not in use!

Putty eraser

This is always useful and I keep one with my sketching materials.

Water-soluble art pens

These pens resemble cartridge-type fountain pens and they are available in black and sepia, and with an assortment of nibs. When a drawing requires a more fluid, or dispersed look, these pens are lovely, but care needs to be taken – do not use too much ink to start with if you are using watercolours, or outlines will merge with the paints and run!

Brush pens

Waterproof and water-soluble sets of these pens are available in black, sepia or colour with a variety of 'brush' widths. They are excellent for sketching because they resemble brushes with a constant supply of colour! Easy, free movements can create bold drawings and they are ideal for areas of colour.

Graphite pencils

These pencils range from very hard (9H) to very soft (9B). Halfway between the two are F and HB. I like to use the soft end of the range (3B to 7B), as these are great for creating dark, black marks on quick sketches. I use only one pencil when sketching outside – a 5B or a 7B, so that I can create a range of tones. I use a harder, lighter pencil for initial drawings when using watercolour. You can also buy solid graphite sticks for strong, bold work. These will shatter if dropped, so treat them carefully!

Water-soluble graphite pencils

These are extremely useful as they provide quick wet tonal areas. There are many brands to choose from, but I always buy the softest and darkest ones available. They can also be used as a dry medium for crosshatched tonal sketches.

Water-brush pens

The transparent bases of these pens are filled with water and the brush tops are screwed to the bases. They are an ideal accompaniment to water-soluble pens and pencils when you are planning a few simple sketches and you want to travel light. It saves you carrying a water container.

WATERCOLOURS

Watercolours are available in a large range of lovely colours and they can be bought in pans or tubes. They are excellent for making quick sketches and capturing the colours, mood and atmosphere of a scene or place. The sketch can then be worked up into a finished painting back in the studio. If you can afford it, buy artists' quality paints – they are better than the students' colours and they mix well. I prefer to squeeze tube paints into the pans of my palette allowing them to dry before closing the lid. I have a tiny pan set for sketching outside and a larger one for studio work (see below). Although I hardly ever use more than five of six colours in a painting, having a wide range of translucent and opaque colours available gives me more choice.

PAPERS

Watercolour papers are available with different surface finishes: Hot Pressed (HP) is smooth; NOT (Cold Pressed) has a slight texture; and Rough is heavily textured. All these types of paper are made in different weights (thicknesses) ranging from 190gsm (90Ib) to 640gsm (300Ib).

I like to use sheets of 300gsm (140Ib) NOT watercolour paper for finished paintings. Sometimes I secure the sheet of paper to a thick piece of cardboard, fitted with a heavy paper flap to protect the finished work. I also have a rectangular hardboard base with a lift-up aperture mount between which I secure my paper – this gives a white frame to the painting.

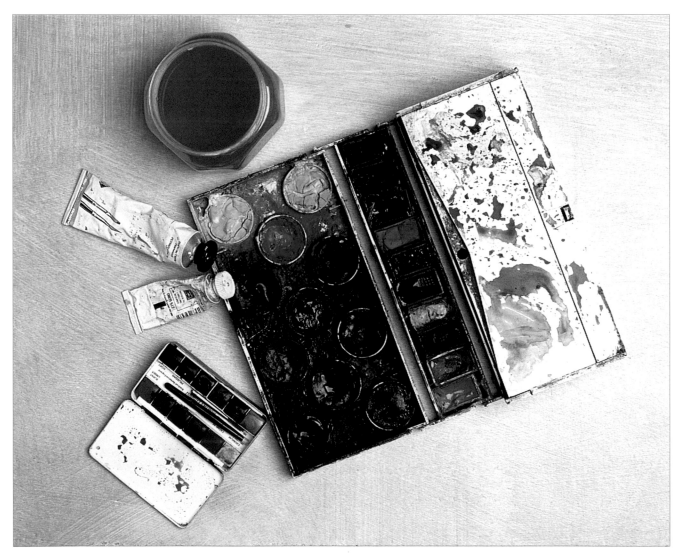

The colours in the small pans of my large palette are (from the top down): Payne's gray, sepia, Hooker's green, neutral tint, cobalt violet, cobalt blue, cadmium yellow, burnt sienna, yellow ochre and cadmium orange.

The colours in the large pans are (from the top down): leaf green, Naples yellow, Cerulean blue, Winsor blue, Vandyke brown, alizarin crimson, cadmium red, black, olive green (light), olive green (dark) and brown madder.

BRUSHES

There are many brushes available. They come in a variety of shapes, sizes and quality. Selecting the right ones can be quite daunting. To start with, I would advise you to buy a few of the best that you can afford, then gradually build up a collection. I suggest having at least one small round brush for general work and middle distance details, a rigger for fine details, and two flat brushes. Use the small flat brush for blocking in buildings, trees and objects with sharp edges, and the large one for applying washes.

I use just one brush which I designed myself. It is wedged-shaped with a fine rigger tip, and is specially made for me. It provides all the wash and detail action I need and is ideal if you want to travel light!

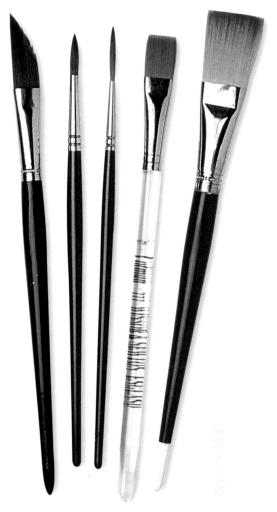

OTHER EQUIPMENT

Masking fluid This is used to create highlights on a finished painting. I apply it to the surface of the paper before painting, or use it over a base colour prior to applying a wash. I always use a ruling pen to apply masking fluid, as it can ruin brushes.

Sponges These are excellent for the texture of trees, foliage and sea spray. Natural and man-made sponges give different effects, so try both.

Candles A candle (wax resist) rubbed on to the paper is ideal for creating highlights such as sunlight on water and snow.

Plastic food wrap An unusual, but very effective means of providing texture. It can create exciting backgrounds and some good flower and rock effects. The wrap is applied on to wet washes, pinched into shape, then left in position until the paint is dry.

Plastic card A redundant credit card can be used for dragging paint about, lifting edges and scoring narrow highlights.

Paper towel This is vital for mopping up spillages, but I also use it for lifting out colour.

Black bin liner If you are going to sit outside in cold weather, a large black bin liner, pulled up over your knees, will keep you warm inside!

Camera Throwaway cameras are super if weight and bulk is a problem, but one with a telescopic lens is better. This lens allows you to capture detail from a distance, and candid images of birds, animals and children without them noticing you.

Stool While you are out and about, it is a good idea to take a lightweight ruck-sack type stool with a bag attached. It needs to be large enough to carry a water pot if you are taking one. Plastic containers with airtight lids make good water pots.

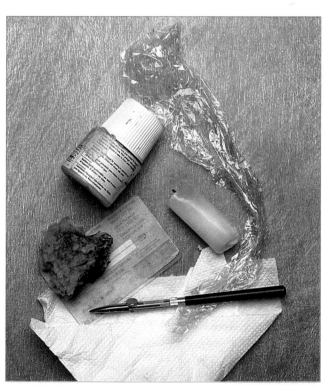

Materials for creating highlights and textures: masking fluid and a ruling pen, plastic food wrap, a candle, an old plastic credit card, a piece of sponge and some paper towel.

Getting started

Whatever type of artist you are – a professional, a serious amateur, a weekend artist, or a beginner – a few crucial lines, some written notes and, maybe, a couple of photographs, will help capture forever a fleeting moment of time that sparks your interest. You never know when these moments are going to occur, so you must be prepared. Personally, I never leave home without a small sketchbook and a pen or pencil in my pocket; I might forget my keys, but never my sketchbook! Remember that you only have a brief time in which to record a scene, so it is important to get all the right information down quickly and accurately.

When I see something that captures my imagination I ask myself why it does so. Then, I say out loud why I like it! Whatever the answer, I try to capture the movement, the shapes, the contrasts or textures immediately.

I have been painting for many years now, and my collection of sketchbooks are as dear to me as my family. They are filled with memories of people, places and objects that I have come across over the years. Some of the sketches are just doodles to capture a particular pose or an interesting shape, others are more detailed, worked up in whatever medium I have to hand, and include handwritten notes about colours, tones and textures. I never discard anything, and many of my favourite paintings have been inspired by old sketches.

TIP SKETCH IN COMFORT

On a sketching expedition, dress in something comfortable and always carry a lightweight waterproof and a cardigan – even in summer or in a hot climate! When you are concentrating on sketching, you can easily forget how cold it can become.

If possible, carry a small stool so that you can sit in comfort; mine is combined in a rucksack.

A black plastic bin liner can be extremely useful in inclement weather conditions. Pop your legs inside the bag and they will be protected from cold winds. It does not look very fashionable, but you will be warm.

These small farmyard studies were worked up in sepia water-soluble pen. I loved the clutter and machinery and the curves of the pecking hens!

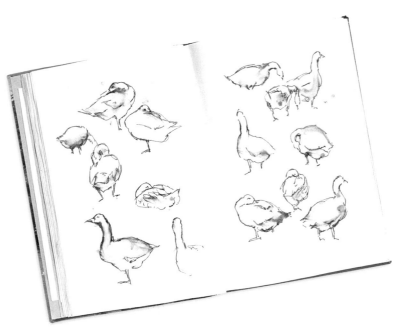

These rabbits, worked up in pencil, were a delight to sketch as they formed gorgeous and varied shapes.

Use simple free-flowing lines (you do not have to be very accurate at first) and concentrate on the very 'essence' or 'action' of the subject. Work up various widths of line; heavy ones to denote forceful and active feelings and thinner ones for distance and structure. Support these with accents of shading to give depth and contrast.

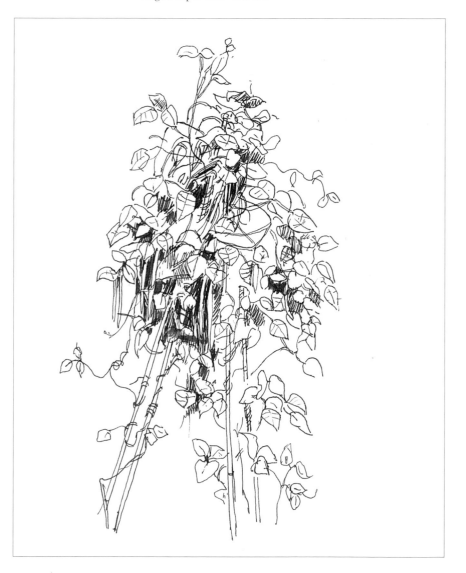

Runner beans sketched with waterproof pens. It was quite a challenge to sketch the fascinating negative shapes of these beans, some of which were in sharp contrast to adjacent shapes. Often this type of sketch can be done as fast spontaneous scribbles. Keep the pen or pencil continually on the paper, hardly looking at what you are drawing, but concentrating deeply on the subject. This method can add a freshness and freedom to your sketching which can give some unexpected results.

USING SKETCHING MATERIALS

Never be afraid of using different mediums, either on their own or mixed together. The images on this page show the same scene sketched in different ways, while opposite, I have included a finished painting of the same scene. The sketches were the result of an exercise I set some students while on a painting holiday in Greece. Every time we left our courtyard, we were confronted with this adorable doorway and hibiscus plant, so it was quite handy to use this as our subject.

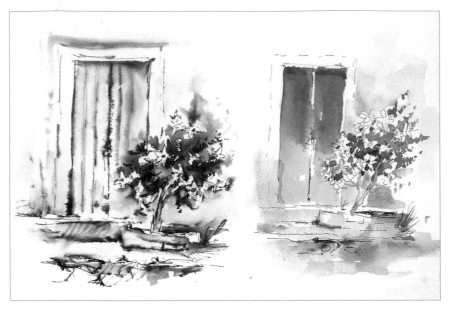

In this image, the doorway was drawn in with pencil, then overlaid with a network of non-waterproof sepia ink, adding more detailed work in the darker areas and much less in the lighter ones. I then used a wetted brush to coax water over the doorway allowing it to seep and bleed into a diffused tonal wash. I added a tiny spot of blue for the wall colour and mid green for the foliage.

In this version of the scene, I drew the basic outlines using a steel-nibbed pen and black waterproof ink. I worked quickly to produce fine broken lines and light scribbles for the foliage. I then used watercolours to block in the shapes.

TIP COLOURS FOR FLOWERS

Flower colours can be very complex so analyse them carefully. Try out colours on a piece of paper and make notes about different mixes. These are just as vital as the shapes and tones on the sketches. Get things right before committing yourself to a finished painting.

The hibiscus colours are alizarin crimson, vermillion and permanent rose. For sunlit petals use weak washes of these colours. For the mid-tone areas, darken the wash with more pigment. At the flower centres, mix at least two colours together. For the shaded areas add touches of cobalt blue to the reds.

Greens are often regarded as a problem. Ready-mixed greens – Hooker's green, emerald or viridian – can look artificial, but they can be mixed with other colours to provide a wide range of natural greens. Add yellow ochre or cadmium yellow to the ready-mixed green for pale greens; burnt sienna or cobalt blue for mid greens; and sepia, violet or deep blue for a range of dark greens.

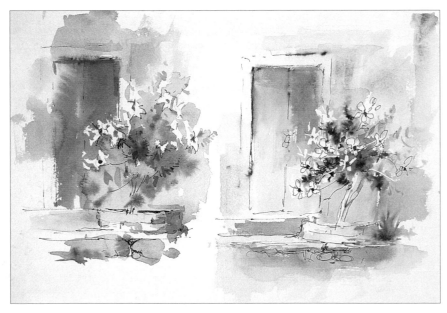

Here, I worked up a free-flowing watercolour study, then, when this was thoroughly dry, I penned in detail with sepia ink.

In this final study, I made an initial drawing with a mixture of waterproof and non-waterproof sepia inks. When I then added watercolours on top, some the non-waterproof ink ran into the colours while the waterproof ink remained stable.

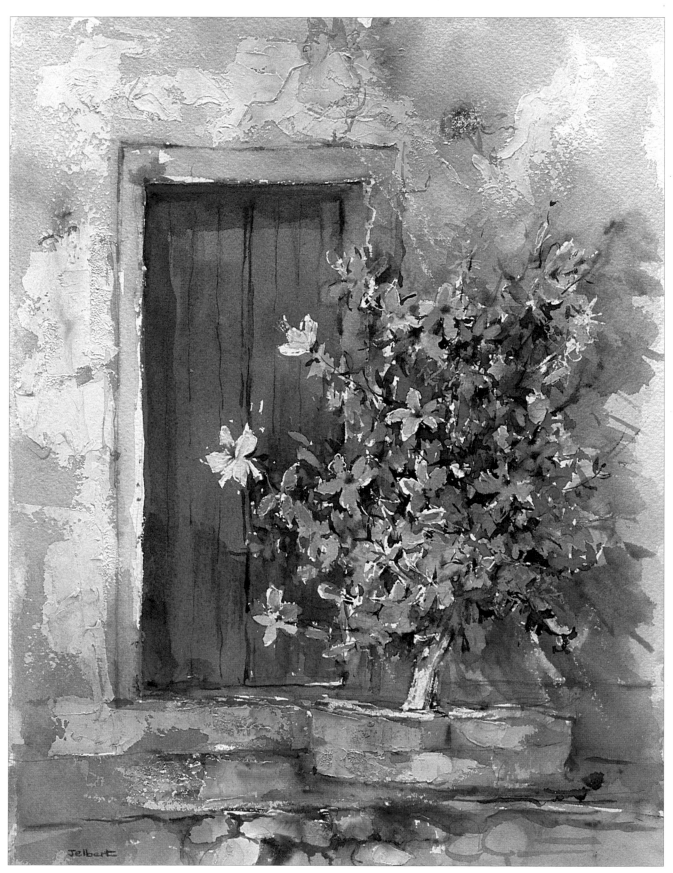

The Finished Painting

This composition was painted from the studies opposite using a mixture of inks with watercolours. This combination of techniques creates a fluid and gentle feel in the shaded areas and gives a more structured look to the stones and foliage.

USEFUL SKETCHES

If your sketches are to become a reliable reference source for future paintings, you must include notes about colours that you see. These notes are very personal. There are no standard rules or codes to follow, so invent your own form of shorthand. But, remember that you must be able to read your notes as well as write them! Only practice will perfect your skills. Here and elsewhere in this book I suggest things that have helped me with my sketching.

Do not be tempted to rely on photographs for this aspect of sketching. With the busy lives we lead, it is an easily-formed habit, but, although photographs have their uses, the colours reproduced often bear no relationship to those of the subject.

If you are sketching with coloured water-soluble pencils or watercolours, try to make the colours as accurate as possible. On the other hand, if you like sketching with graphite pencils or ink, annotate the finished sketch with written notes about the colours. Sometimes dots or small slithers of each colour can be added to the sketch instead of words.

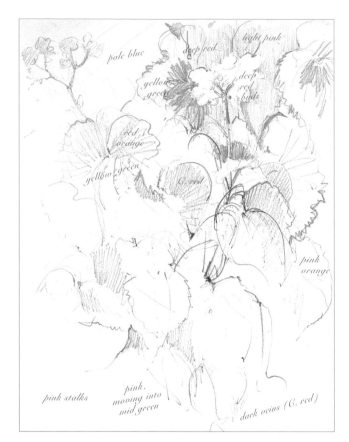

Pencil sketch with handwritten colour notes.

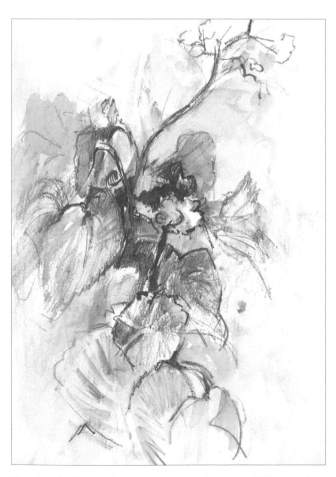

This sketch of a pot plant was worked with water-soluble pencils.

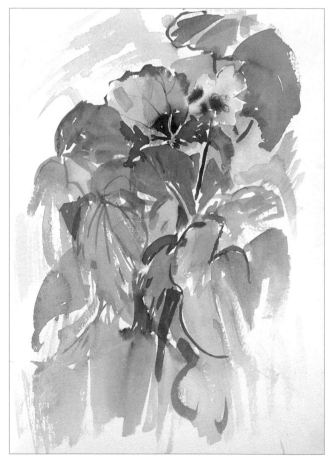

Here I sketched the same subject as above with watercolours.

18

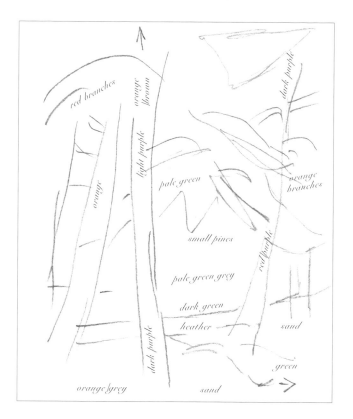

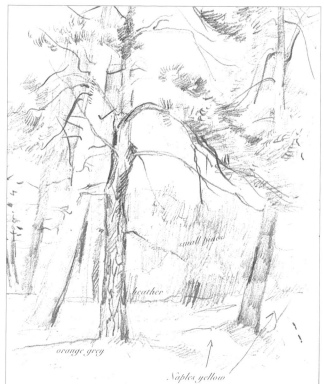

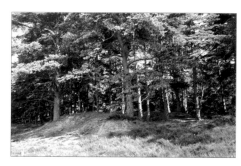

This painting of a woodland scene was worked up from the sketchbook references above.

The photograph of a large group of trees is a general reference of the scene; I chose to simplify the composition and to concentrate on just a few of the trees. A lot of colour information was needed, so I made two pencil sketches. One, top left, is a very simple sketch of basic shapes on which I added most of my notes. The other sketch is more detailed and shows different textures and tones.

Some artists like to make a regimented list of notes on a separate page, but I prefer to have them on my drawings.

TIP SKETCHING DETAIL

More often than not, one-third of all detail can be left out.

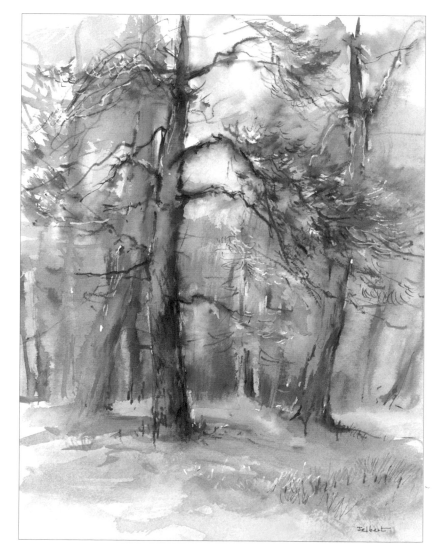

Capturing details

Collecting just the right material for a future painting can be quite a task, especially if you are under pressure and time is a limiting factor. Quite often, when you start sketching, the more you see, the more you add, and your sketch can become very detailed and crowded. Sometimes, this is not bad practice, as you may well be able to develop several compositions from just one sketch. If your sketch is too scanty and brief, there is a danger you will forget what is in that blank space, and you may not be able to recreate it properly even with a bit of imagination! If you have the time, it is worth the effort of producing a full sketch, rich with information and ready to work from – perhaps backing it up with a photograph or two.

Seeing things properly is all important, so be extra curious in your observations. Whenever you have a spare moment, take a look about you. Spot the extraordinary array of surfaces – the carpet, your clothing, the cat, a decorated pot, or your own hair. How do we sketch these? Look again, more closely this time, and absorb the rhythms and patterns you see. Do they have hard ridges, dots or scales, or is the texture wispy or feathery? Note how one surface compares or contrasts with another, then try to imitate them using lines, dots and dashes and by varying the thickness of your drawing line. Slowly, you will develop your own 'artistic language'. Practice will make you more observant, and will help improve your sketches and paintings.

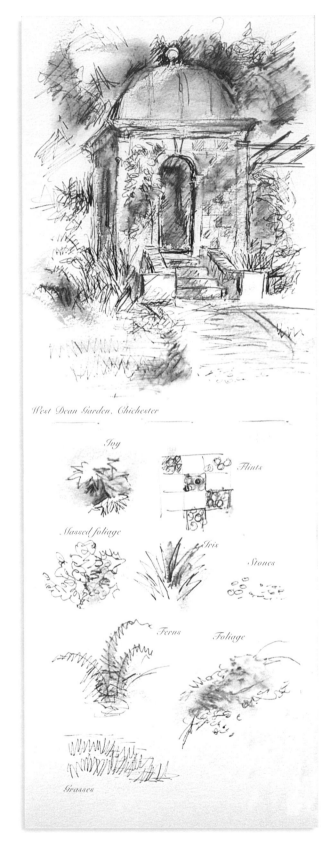

West Dean Garden, Chichester

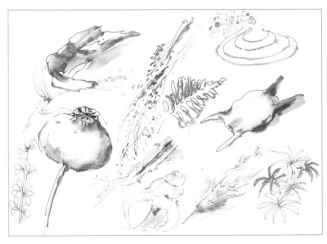

These studies in waterproof and non-waterproof inks, show the different textural qualities of shells, leaves and dried plants.

Here in this study in the gardens at West Dean College near Chichester, my class and I had an enjoyable day sketching and one of the features we liked was this small flint building. We explored the variety of plants, steps, building materials and various surfaces around this busy corner.

The two watercolour sketches on this page, a bell tower and a detail of pomegranates, were painted while on a painting holiday in Greece.

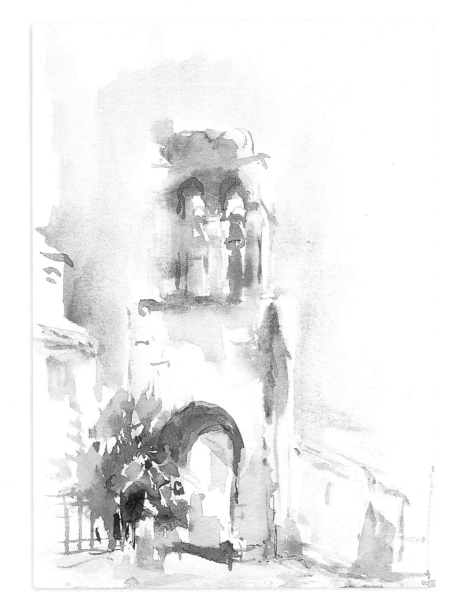

I used the wet-into-wet method to paint the bell tower so that it gently blended into the blue wash of the sky. This technique softened all the edges at the top of the tower emphasizing the archway and door which have harder edges.

Cascading over one corner, a beautiful display of pomegranates provided a sharp contrast to the pale area beyond. The bright colours of the fruit and foliage help draw the eye into the middle distance.

I loved the collection of these delightful pomegranate fruits so much that I decided to paint them for the sheer joy of doing so. I also bore in mind, however, that they could be a useful reference for future work.

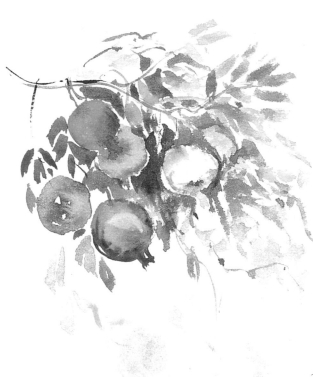

How to sketch

Composition is the organising of this chaotic world into something artistically pleasing. We often have to move things about and exaggerate tones, shapes and colours to arrive at an acceptable balanced picture. The subject or scene has to play on your heartstrings, and you need to sketch it before it vanishes.

FOCAL POINT

Look at the subject and decide quickly what part is the most vital, then make this the focal point of your composition. In the example here, painted in watercolours on a two-page spread of my sketchbook, the focal point is the bell tower. It is vital that this point includes the correct ingredients: it should contain the darkest and lightest parts of the scene; it should be the most detailed part of the composition; and the brightest colours should be placed around it. Although there are exceptions, I like to use the 'golden section' rule for placing focal points, as it provides a comfortable balanced picture. Try to avoid placing the focal point on centre lines as this can divide a composition into halves.

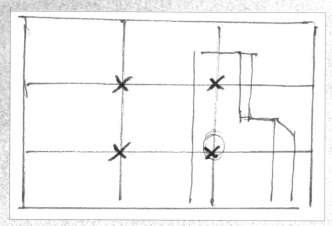

The golden section method divides the composition into thirds, both horizontally and vertically. The four intersections of these lines make the best positions for focal points.

SHAPES

Now place simple shapes around the focal point. Keep everything basic and direct, and develop it into a jigsaw-like study. For this composition, I contrasted the bold straight lines and solid mass of the bell tower with a large sky and simple undulating lines for the background. It helps to have 'rhythm' lines (directional indicators) that lead the eye to the focal point. These could be in the form of a path, a river, a row of fence posts or trees along a hillside or even the formation of clouds – anything that flows or nudges your eyes towards this area.

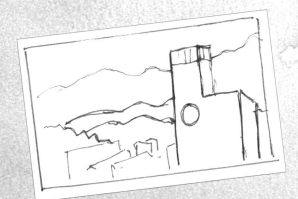

TONAL VALUES

Finally, look at the tonal values.
Ideally try to set darks against
lights or midtones, and *vice versa* –
paintings that lack tonal contrast can
appear flat. Start with the focal point,
then elaborate outwards to
the edges. Your painting is
not a photograph, so you
can alter things at will. You
can, for example, change
the angle and intensity of
the light source to introduce
or reduce the strength of
shadows. Shadows can help
create depth in a composition
and help with tonal contrasts.

TONE

The tone of any colour varies from light to dark, and is governed by the ratio of pigment to exposed white paper. Transparent watercolours and inks, for example, can be diluted to form a range of tones from the weakest wash through to pure pigment. With pencils and pens, a similar range of tones can be achieved by varying the density of marks (scribbles, dots, dashes, crosshatching, etc.) made on the paper. Work up gradated columns of tone (see below), then number them from 1 (the lightest tone) to 6 (the darkest). Different mediums have different characteristics, and only practice will allow you to represent a particular tone in your chosen medium.

The tonal exercise (right) could help you build up confidence with using tones, before you start working on more complex compositions. The more you practise, the more you will discover the subtlety of tone. You will soon realise that there are more than just six tones, and that you will want to refer to a tone as, say, 2½ – somewhere between 2 and 3.

Tonal exercise

Set up a simple still life composition with different coloured papers and, maybe, a pen. Bend the papers into shapes that catch the light at different angles.

Make a tonal chart in the medium you want to use. Draw the outlines of the composition in your sketchbook, then, referring to your tonal chart, number all the surfaces and add colour notes.

Cover the still life, then working from your notes, shade in the sketch. When this is complete, compare it with the original.

Pencil Pen Sepia

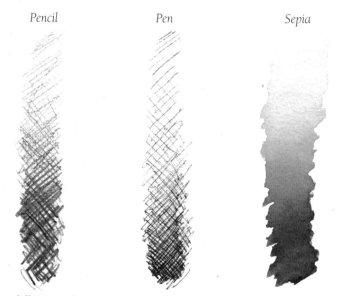

Use different mediums to build up a library of tonal charts.

Start with a soft 4B pencil, then, using hardly any pressure, cover a small area of paper. Now, with slightly more pressure cover another small area beneath the first. Continue building up the column with denser tones until you have an almost solid black.

Use a steel-nibbed pen to work up another column with crosshatching, varying the intensity of marks from almost nothing to almost solid.

Now, using a dark watercolour (I used sepia in this example) work up a third column. Start with a watery wash and build up to neat pigment.

Always start by marking the lightest and darkest areas of a composition. Then, having committed yourself to the extremes, you will find it much easier to decide on where to place the other tones. Finish the sketch with relevant colour notes and you should have all the vital information to allow you to construct a finished painting at a later date.

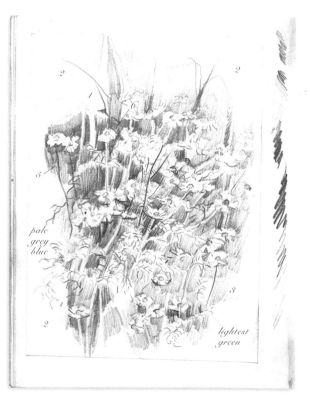

24

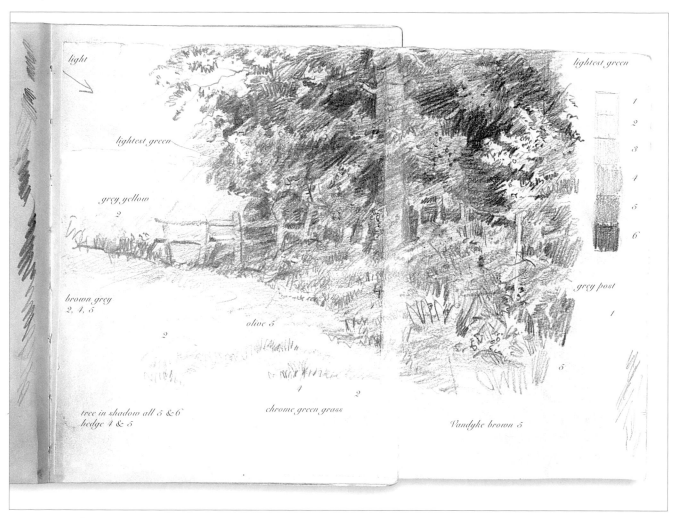

Summer Hedgerow

This carefully constructed sketch corresponds to the tonal chart in shading and bears the numbers and colour notes needed for future reference. Note how this sketch is on a large, separate sheet of paper which I folded and stuck into my sketchbook. Your sketchbook does not have to be neat and tidy, but it must contain all the relevant information to enable you to construct a painting at a later date.

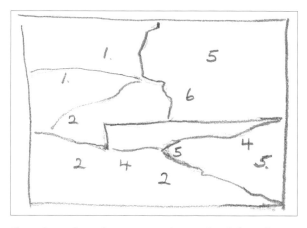

If you do not have the time to work up a detailed tonal sketch, you can at least rough out the shapes and add tonal numbers and colour notes. The jigsaw-effect sketch above, simple as it is, will help you decipher the shapes and structure of a subject.

Apart from indicating the light and dark areas of a composition, you can also use tones to denote perspective. Note the differences in tones and spacing from the foreground to the distance in this sketch.

25

Whenever possible, I always make a tonal study of a scene before working up a colour sketch. Tonal studies help clarify and balance the design of the composition. Having both types of reference material gives you a strong base to work from. Try not to leave any blank spaces – you will never remember what you have left out!

Studies of delightful scenes such as Dedham Church, from Flatford River, look wonderful in an elongated landscape format. Spreading your sketch across two pages of the sketchbook allows you to create this shape without having to make the sketch too small to be really useful.

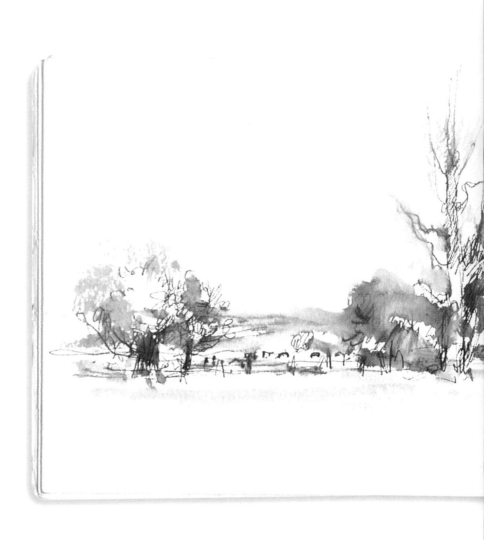

Tonal sketch

I spent just fifteen minutes in situ, to sketch this tonal study with a sepia water-soluble pen. The assortment of trees, buildings, people, animals and the gateway all had to be simplified, but the path meandering towards the church, provides a perfect lead-in to the focal point.

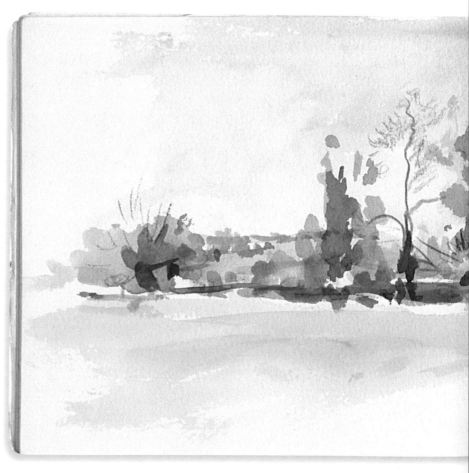

Watercolour sketch

I have a 140gsm (90lb) watercolour paper sketchbook which is perfect for both sketching and for painting small full watercolours. For this colour sketch, the range of greens are made from Hooker's green mixed with yellow ochre, cadmium yellow, burnt Sienna, cerulean blue and violet. The animals, foreground and buildings all echo these colours. For speed, I used grey and burnt sienna water-soluble pencils for some of the branches on the trees.

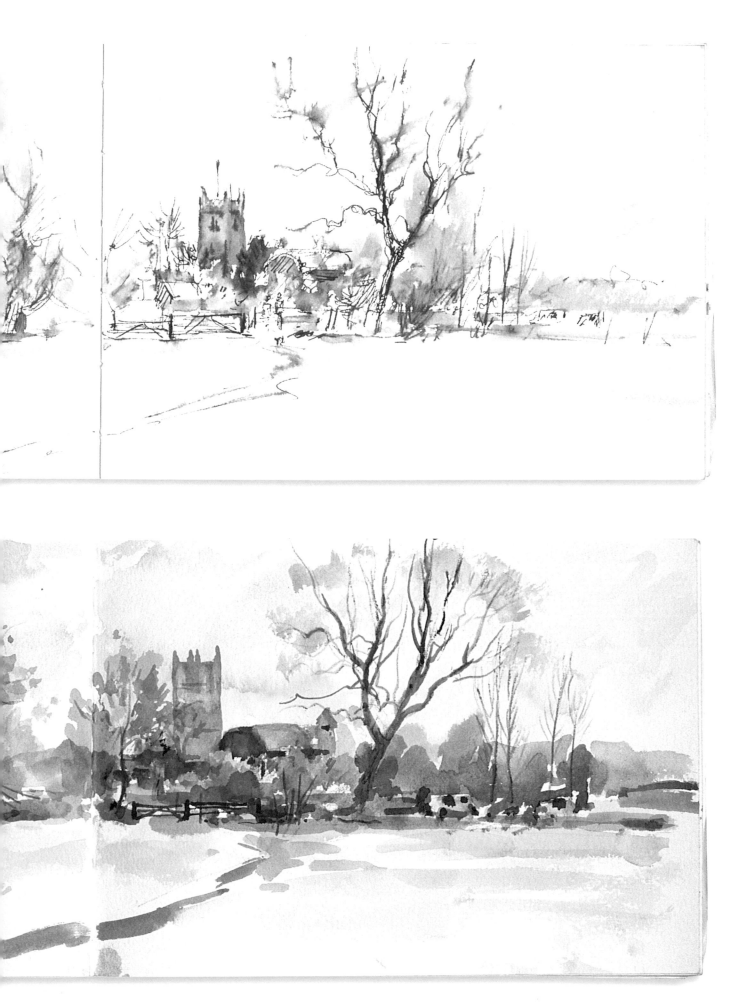

TEXTURE

I love twiddling and doodling in my sketchbook, and this is a page of
experimental images in which I used a variety of strokes to capture
different textures. Generally speaking, we are not good at really seeing
things until we try drawing them and, without good drawing there is no
good painting. One way of learning how to see the different textures in
a landscape is to look at a small object such as a shell, a rock or a piece
of wood. From a distance, these will be seen just as simple
three-dimensional shapes. When you look at them closely, however,
you will see that they have fascinating surface textures. Place them
under a magnifying glass and they look gorgeous. Having got used to
looking at small objects in this way, try looking at a wider scene and
capturing the textures of different parts of the whole. Investing time in
this type of exercise will enrich your future paintings.

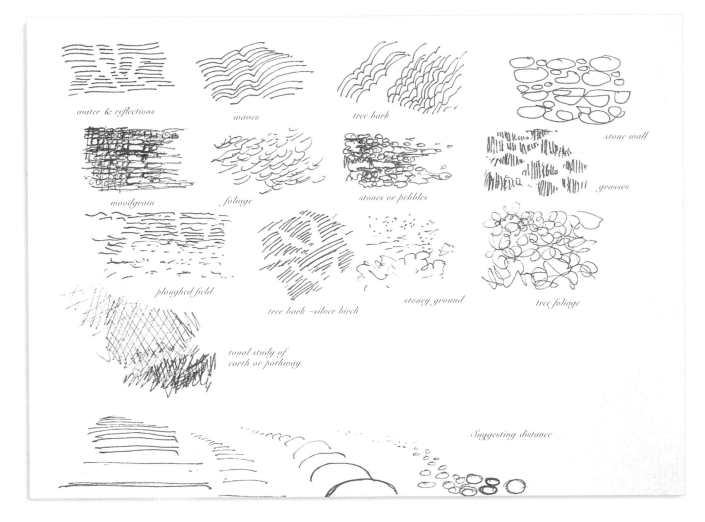

*This page from my sketchbook shows different textures produced by a variety of strokes.
Be selective when working up doodles such as these and just suggest texture. Do not try
to draw everything.*

I love sketching with water-soluble pencils, and these quick doodles from my sketchbook show some of the methods I use to capture texture in colour.

Wet the tip of a water-soluble pencil and create a coloured wash with a brush. A two-toned wash can be obtained by holding two pencils together and applying both colours to the brush.

Crosshatch different colours of water-soluble coloured pencils, then apply a wetted brush to the marks and blend them into a wash.

A mix of two dry colours on the paper can then be wetted to form a range of hues.

A brown or burnt sienna water-soluble pencil is excellent for sketching and painting branches.

Marks made with a wetted tip of a water-soluble pencil straight on to the paper will be dark and indelible.

This leaf was created by laying a wash, taken from the wetted tip of a water-soluble pencil with a brush, then adding the details with the tip of the pencil.

Drag the side of a wetted pencil randomly across the paper to form a shrub or tree.

To draw a clump of grass, hold two contrasting pencils together, then use a flicking movement to create tapered strokes.

Spatter a wetted tip of a water-soluble pencil on to a dry or wetted surface to give a good pebble effect. I used blue and burnt sienna for these marks.

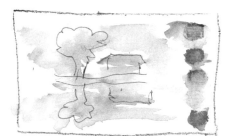

Place small squares of dry pencil colour in a corner of your sketchbook to give you a good lightweight palette of colours to use for quick sketches.

Create a large colour wash by shaving the pigment from the pencil point on to a wetted surface, then brushing the pigment and water together. Form clouds by lifting out some of the colour with a small piece of paper towel.

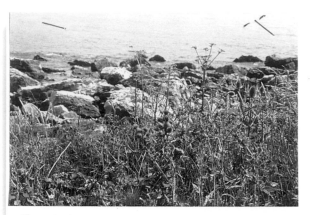

Mauve thistles
Yellow flowers on cow parsley
Brambles
Pinky grasses

Chapman's Pool, Dorset

These two pages from one of my sketchbooks illustrate an exercise I set my students. I give them a photograph and ask them to sketch the scene, highlighting the different textures they see. This composition includes grasses, rocks and a selection of weeds and other foliage.

Try to create contrasting textural qualities as well as tones; if necessary, you can even exaggerate the texture in one area to counter something similar near by. Note how I have used a variety of line weights to help create depth and perspective in my textural sketch – thick, heavy lines in the foreground, soft and thin ones in the distance.

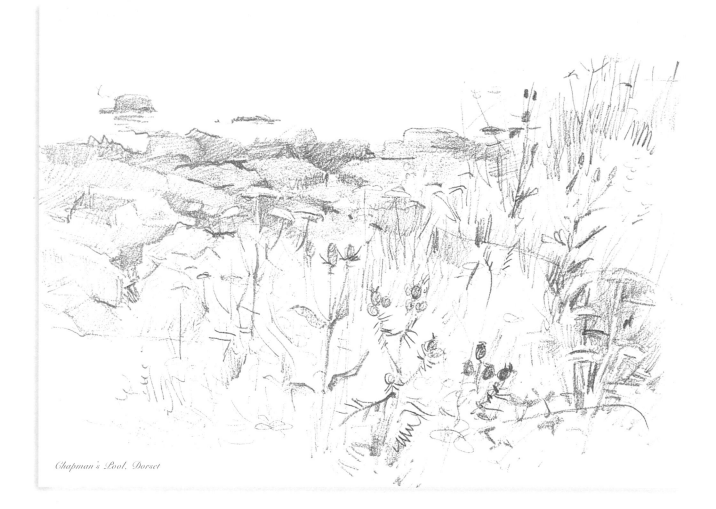

Chapman's Pool, Dorset

Colour notes

It was late autumn, a season I simply adore, when I happened on this country scene. The lush greens of summer had started to fade, and much of the foreground foliage had disappeared leaving stark, skeletal shapes. I only had a sketchbook, a few pencils and my camera with me, but I still managed to record enough information to create a finished painting in my studio (see page 32).

First, I made a tonal sketch of the composition. I was so pleased with the result that rather than spoil it with colour notes, I decided to make another sketch.

For this second, much rougher, sketch I simply marked in the outlines of the basic shapes. I then made lots of handwritten notes about the colours I could see. On this particular sketch I have made references to specific colours (burnt sienna, light red, etc.) and to general colour hues (orange tint, brighter green, etc.) I have also made separate notes about particular elements of the image (barbed wire, cow parsley and dandelion). You can never make your notes too detailed, especially if you do not have the equipment or time to make a coloured sketch.

I also took a few photographs. Notice that in the one reproduced here – taken from the same viewpoint as the sketches – there is a much wider field of view than the sketch. Photographs do have their uses, they are great for showing lots of detail, but I never rely on them for accurate colour reproduction.

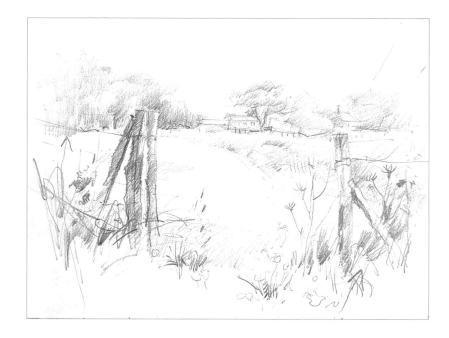

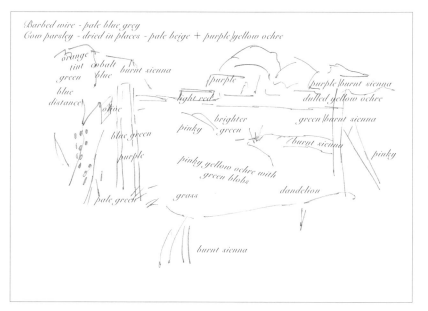

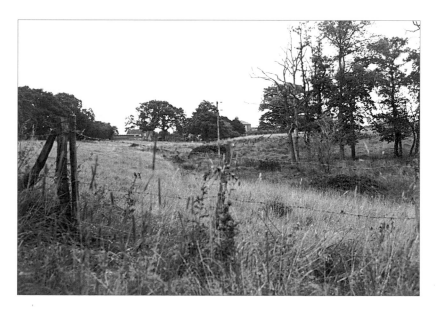

The Finished Painting

I worked up this finished painting in my studio from the reference material shown on page 31. I sketched in the whole scene, carefully formulating where my focal point should fall. I applied masking fluid for the light grasses and cow parsley, then used a simple palette of mixed greens, burnt sienna, yellow ochre and cobalt blue to paint the picture. A wet-into-wet sky diffused into the foliage on the left-hand side, helped create depth and distance. When this wash was dry, I painted the buildings and foliage on the right-hand side and the foreground area with bolder strokes. The darker grasses and small fence details were applied with water-soluble pencils.

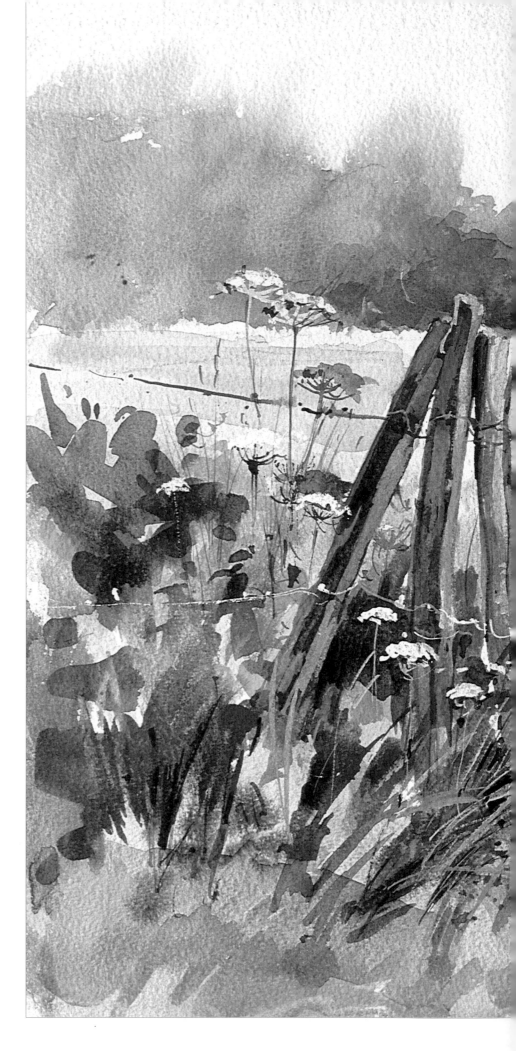

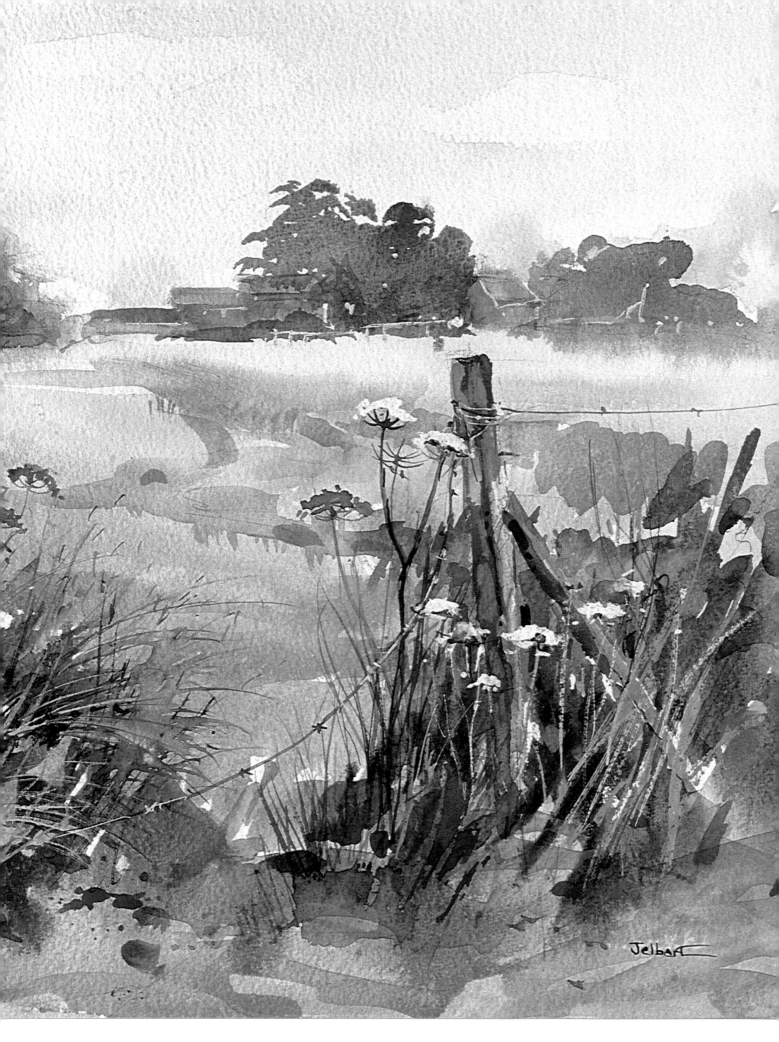

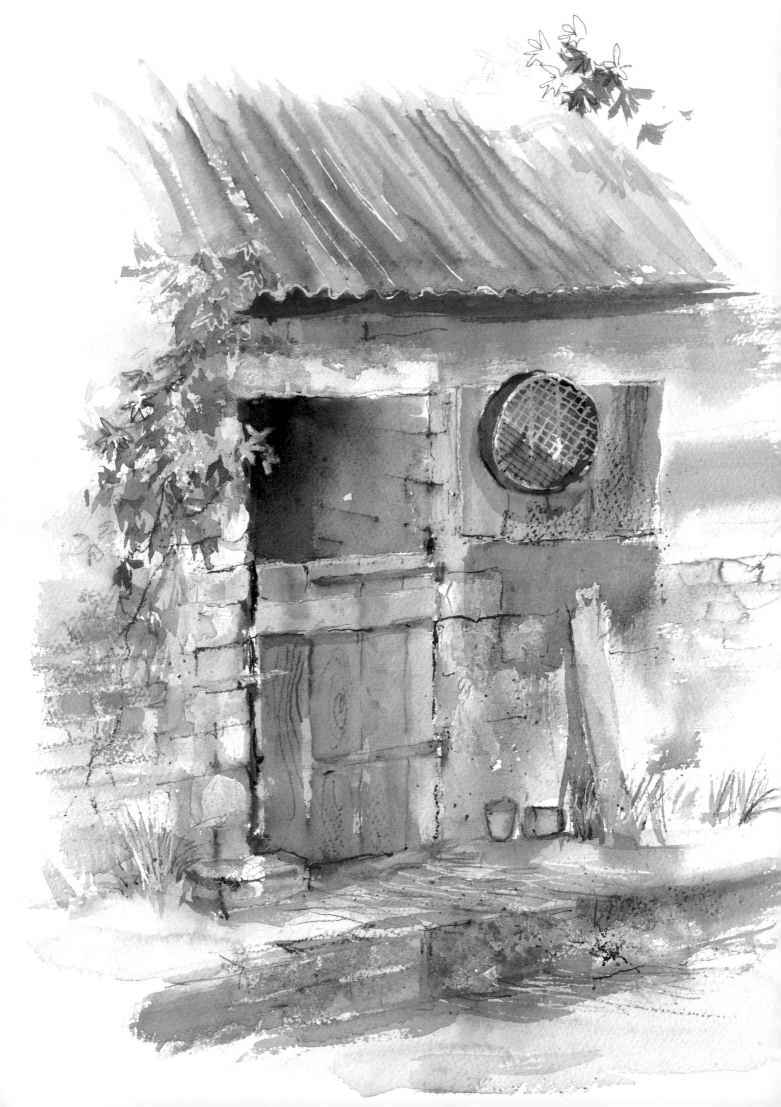

Farmyard Corner

Size: 305 x 405mm (12 x 16in)

Another wave of inspiration for textures can be triggered off by visits to farmyards. Farmyard scenes will widen your range of subject matter and they are wonderland places in which to explore and interpret all types of surfaces! They will provide a real challenge for your imagination, requiring you to become a magician when recreating feathers, stones, wood, grasses and rusty objects with your watercolours, pencils, pens and inks.

The finished painting opposite includes lots of textures worked from doodles in my sketchbook, some of which are shown here. These small details helped me enormously when I redrew the farmyard in my studio as a full painting and I needed to include things in more detail. My doodles are notes to myself, reminding me of pointers that may be useful later on. You are probably doing the same in your sketchbook, or will be very shortly!

We need to remember we are imitating nature and our interpretation will never achieve the perfection and draughtsmanship of natural things. We have to be content with simplifying objects and selecting the elements that form the basic character of our subject.

Apply spiky lines and shapes with light green and orange oil pastels, then lay a darker watercolour wash on top.

Draw the undulating outline of corrugated-iron with water-soluble pencils, then introduce water to diffuse the marks.

Use a waterproof ink to scribble random leaf shapes, then overlay these with strokes of watercolour that echo the ink shapes.

For objects such as chicken wire and straw, draw fine detail with masking fluid before applying watercolour. When the painting is nearly finished and everything is dry, rub off the masking fluid to leave white highlights. Add fine detail with water-soluble pencils or ink.

Use yellow ochre and mixed grey watercolours for stonework, and a sepia ink or sepia water-soluble pencil for the grooves and spacing between the blocks. A weathered effect can be created by applying a cream oil pastel on top of the watercolour when it is still wet or completely dry.

Hold two water-soluble pencils together then use small upward strokes to draw spiky and arched blades of grass.

Wash in the planks of the wooden door, then use similar shades of water-soluble pencil to create whorls and wiggly lines which imitate the woodgrain.

For brickwork use masking fluid to define the mortar joints, then block in the bricks with watercolour.

Alternatively, use the method described above for stonework, but use a light grey oil pastel for the mortar joints and mixtures of orange and pink for the weathering effect.

Test your choice of colours in the corner of your sketchbook.

French window

I love visiting France, and I often go there with students on painting holidays. This scene, of a sun-drenched window with long shadowed tendrils stretching down the walls, intrigued me as soon as I first saw it. I sketched two compositions; one in portrait format, one in a landscape format. I decided to use the portrait format for this demonstration, knowing that I could crop it to a landscape format at the end (see page 45).

The building actually has two similar shaped windows, one above the other, but I decided to omit most of the upper window, leaving just enough to explain the shadow patterns at the top of the picture. I usually like to include road signs, but left the one in this composition out because I felt that it was too distracting.

I love the contrasting textures in this scene; the shutters – precise and orderly – sit well against the random cascade of climbing plants and geraniums.

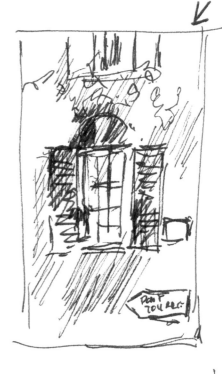

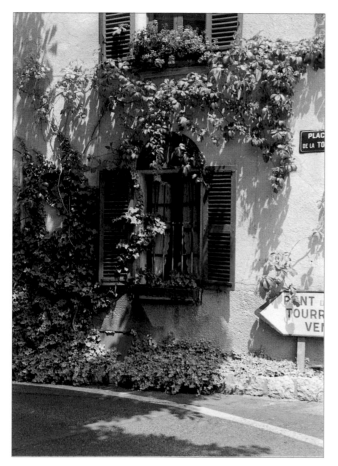

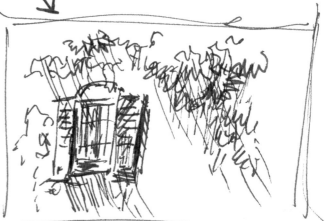

A reference photograph and two quick sketches of the scene that I made at different times of the day (note direction of the light source and the angles of the shadows).

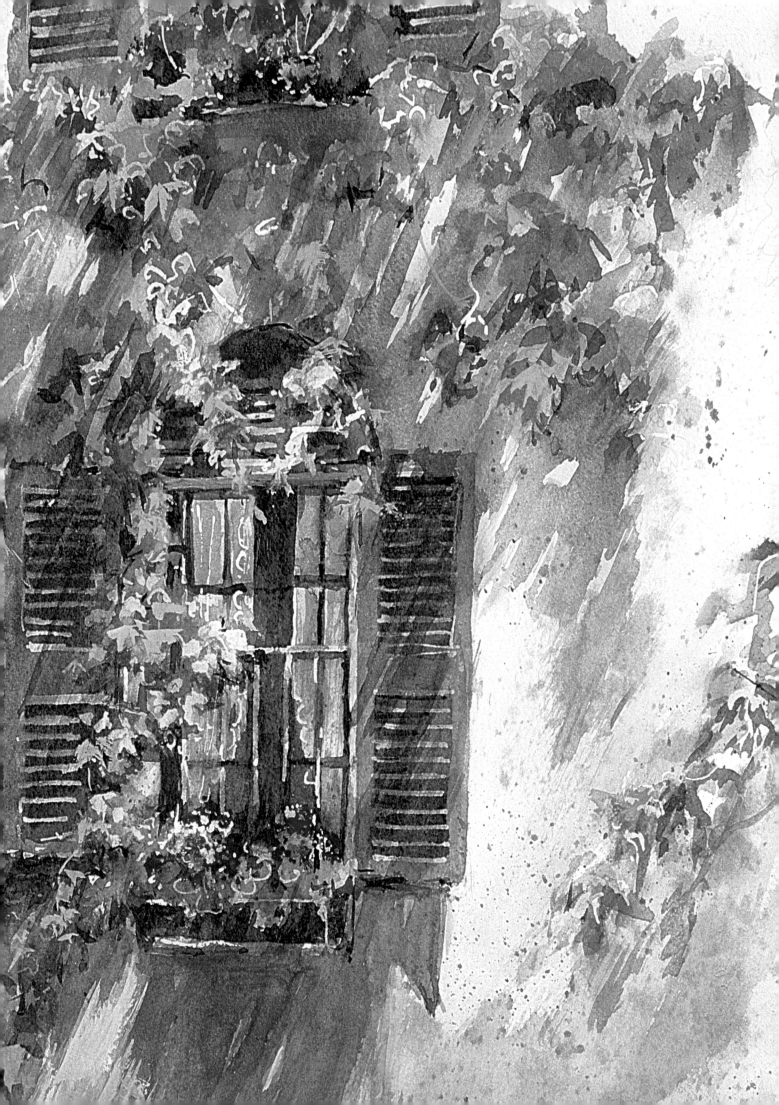

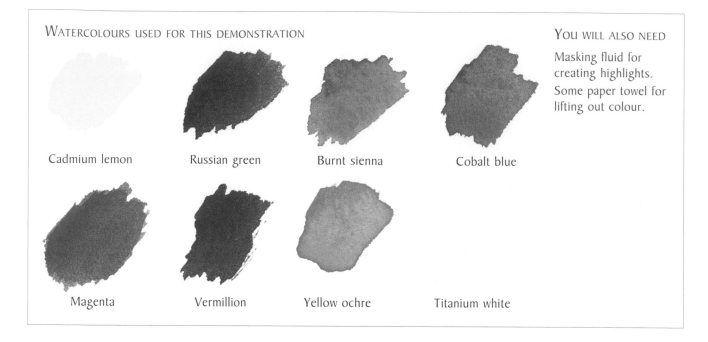

WATERCOLOURS USED FOR THIS DEMONSTRATION

Cadmium lemon Russian green Burnt sienna Cobalt blue

Magenta Vermillion Yellow ochre Titanium white

YOU WILL ALSO NEED

Masking fluid for creating highlights. Some paper towel for lifting out colour.

1 Use the tonal sketch and reference photograph to draw the basic outlines on to the watercolour paper.

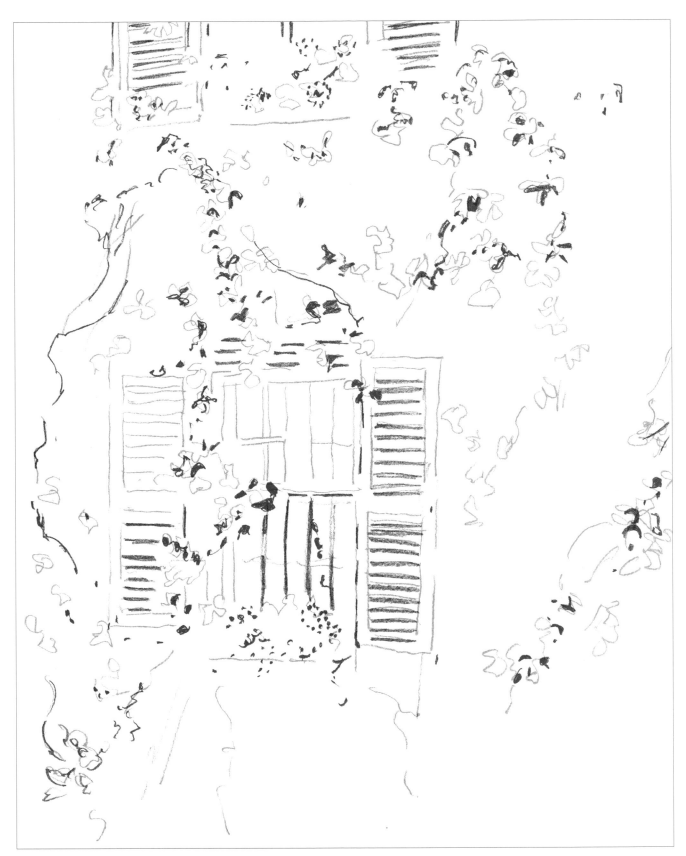

The finished pencil sketch. The red marks are where masking fluid is applied in steps 2–5 overleaf.

2 Apply masking fluid to the bright highlights. Hold the pen at steep angle to draw horizontal lines for the louvres on the window shutters.

3 Holding the pen nearly upright, tap the point on the paper to make groups of small dots for some of the flowers.

4 Holding the pen as flat as possible, move the point in circular movements to create larger puddles of fluid.

5 Draw curved lines by pulling the pen across the paper; twist it to form different weights of line.

The pencilled composition with all the highlights masked out.

6 Mix cadmium lemon and Russian green, then working wet on dry, block in the lighter parts of the foliage taking this colour over the masked out areas. Vary the shades from a pale yellow-green to a mid green.

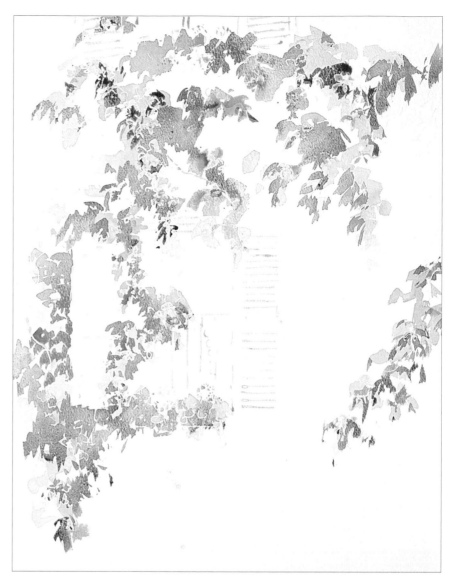

7 Now mix burnt sienna with Russian green to make darker shades of green then paint these colours into the paler marks – work some wet into wet, some wet into damp and some wet on dry.

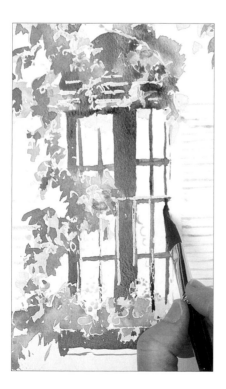

8 Mix a strong dark green from Russian green, burnt sienna and cobalt blue, then paint the window details.

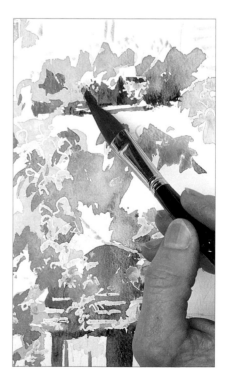

9 Use the same mix of colours to define the shadows and details below the window that bleeds off the top of the composition.

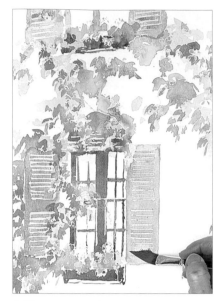

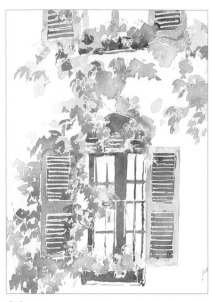

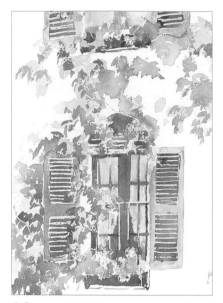

10 Add more cobalt blue to the colour on the palette to make a blue-green, then block in the shutters on either side of the main windows and those at the top of the painting. Dilute the wash for sunlit areas.

11 Use stronger mixes of the same colours to paint in the shadows on the louvres on the shutters.

12 Use cobalt blue with touches of green on the palette to block in the curtains. Indicate folds with vertical streaks of a slightly darker tone. Add more green to the mix, then define the edges of the curtains.

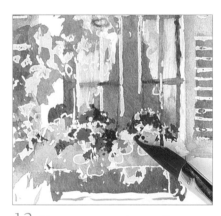

13 Use magenta and vermillion to paint the flowers in the window boxes – use strong colours for the flowers in the lower window box and slightly weaker colours for those in the upper window box. Use the point of the brush to make tiny marks.

14 Wet all the white areas of the wall. Mix a weak wash of yellow ochre and magenta, then, using broad loose strokes, wet into wet, block in the wall. Darken the wash with a touch of burnt sienna, then lay in some of this colour between the windows and below the bottom window.

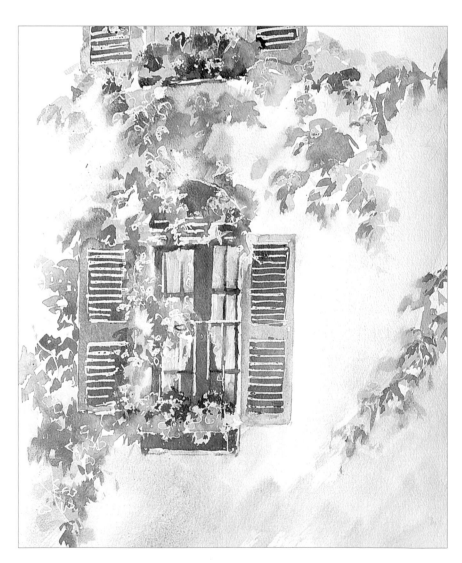

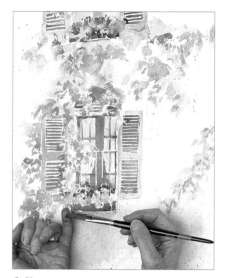

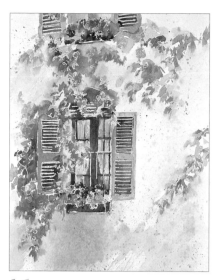

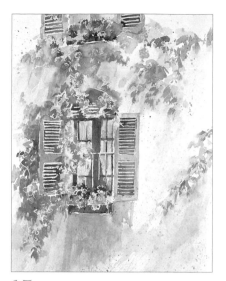

15 Working wet into wet, spatter a mix of burnt sienna and cobalt blue over the walls, allowing some of the marks to blend into the background colours. Leave to dry.

16 Use a mix of Russian green and burnt sienna to strengthen some of the dark green areas – the window frames and some of the foliage, particularly down the outer edge of the left-hand shutter. Leave to dry.

17 Mix yellow ochre and burnt sienna, then, using random strokes, glaze in cast shadows on the wall. Leave to dry.

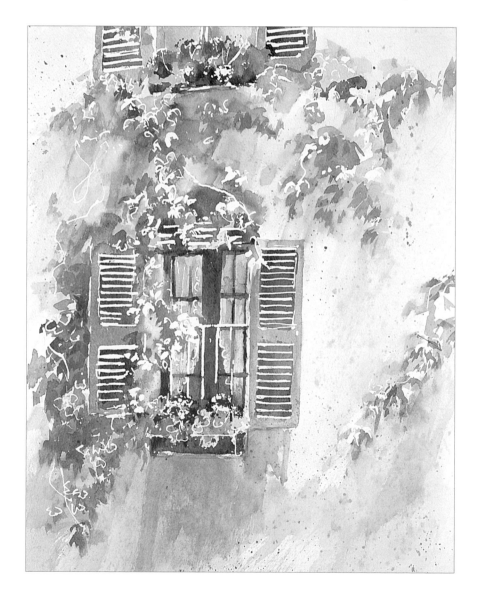

18 Remove all the masking fluid.

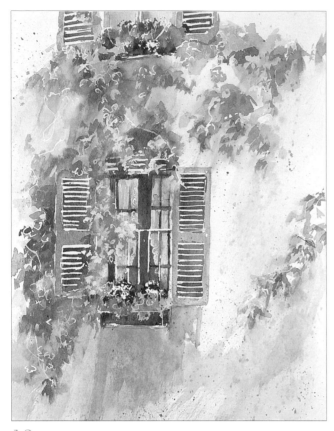

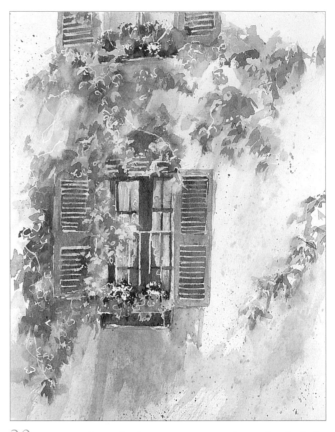

19 Use cadmium lemon with a touch of Russian green to cover some of the newly-exposed parts of the foliage. Add touches of cobalt blue to the shadowed areas of foliage.

20 Mix a weak wash of Russian green with touch of cobalt blue, then glaze over the window shutters.

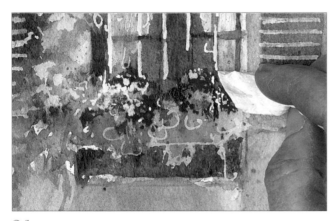

21 Mix a weak wash of magenta, then block in the remaining 'white' areas of the flowers in both window boxes. Use a clean piece of paper towel to dab off excess colour.

22 Mix a violet from magenta, cobalt blue with a tiny touch of yellow ochre (to dull the final colour) then lay in the deep shadows on the wall and the shutters. Reinforce the dark shadows on the shutters. Add small dark marks all over the painting. Finally, add touches of very dark green on the windows and foliage.

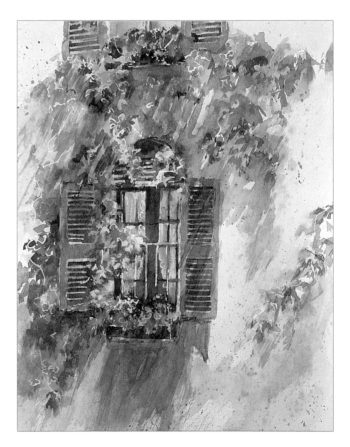

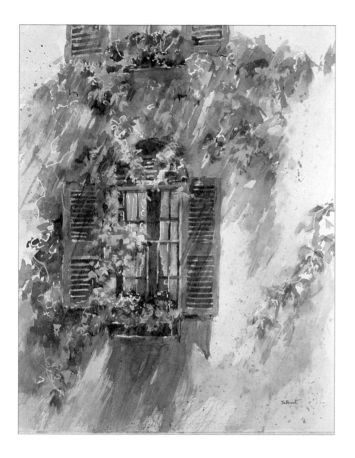

The finished painting

Having stood back and looked at the painting at the end of step 22, I decided to add a few highlights using titanium white mixed with touches of cadmium lemon and Russian green. I also used undiluted Russian green to add a few dark green accents.

TIP MOUNTING THE FINISHED PAINTING

I used a 305 x 405mm (12 x 16in) sheet of paper for this painting. To retain the portrait format, I would cut a mount with a 275 x 375mm (10¾ x 14¾in) aperture and set this centrally over the painting as shown by the red box rule.

Alternatively, you could turn the painting into the landscape format of the other tonal sketch shown on page 36. For this shape, I would cut a mount with a 285 x 225mm (11¼ x 8¾in) aperture and place this over the painting as shown by the blue box rule.

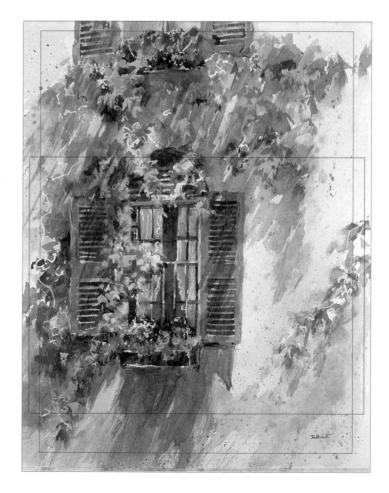

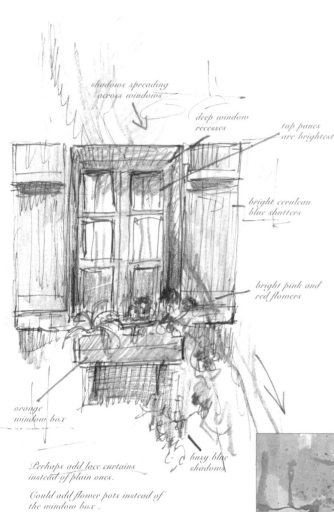

shadows spreading
across windows

deep window
recesses

top panes
are brightest

bright cerulean
blue shutters

bright pink and
red flowers

orange
window box

busy blue
shadows

Perhaps add lace curtains
instead of plain ones.

Could add flower pots instead of
the window box .

Greek Window

Size: 365 x 495mm (14½ x 19½in)

The original sketch for this scene was worked up with sepia and red pens with passages of water-soluble pencil to indicate basic colours. I also included additional, handwritten notes about particular colours and some suggestions about how I could modify parts of the composition.

In the finished painting below, I decided to change the arrangement of flowers. This proved to be an interesting challenge, but I am pleased with the result. Apart from putting the plants into pots, rather than the wooden window box, I also added a lace pattern on the net curtains by saving whites with masking fluid and touching up the finished painting with white gouache. I kept the bright highlights on the glass for extra contrast. The long shadows, the shape of which had to match the new arrangement of flowers, were lengthened and enhanced.

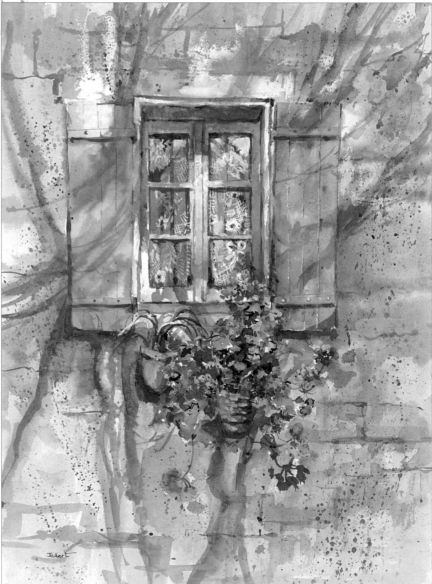

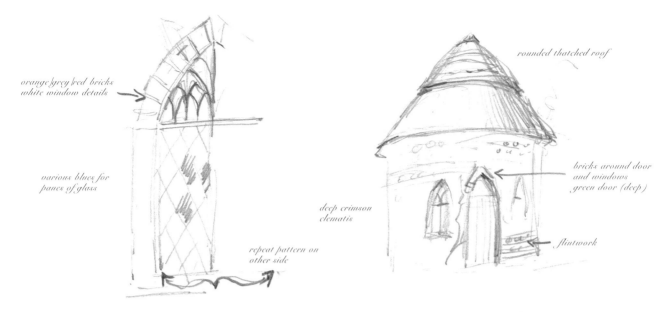

orange/grey/red bricks white window details

various blues for panes of glass

repeat pattern on other side

rounded thatched roof

bricks around door and windows green door (deep)

deep crimson clematis

flintwork

West Dean Window

Size: 305 x 455mm (12 x 18in)

This gorgeous characterful window belongs to the college where I teach several times a year. It is a round house with a tea-cosy thatch. I sketched the whole building briefly, and then selected an arched window for further study. Notice that I used a short cut for sketching the window; I worked up one half in full detail and made a note that the other side was a mirror image of the first. These two sketches, together with their constructive colour notes, helped me to complete the finished painting in my studio.

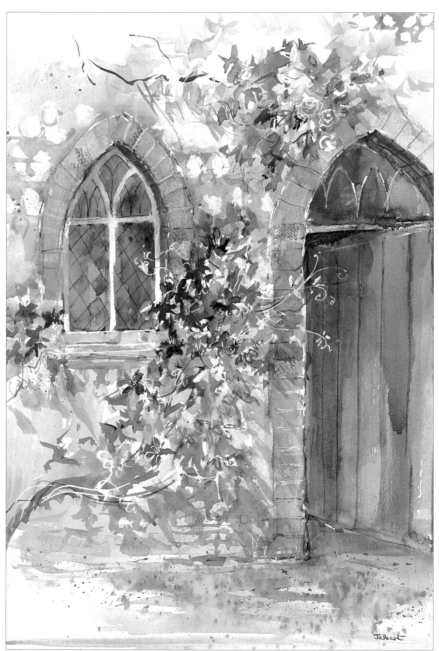

Using sketchbooks

In our efforts to depict a scene that is worthy of recording, we soon realise that we may have a problem. We cannot portray everything – especially a wide landscape crammed with information! Some of the definition and detail must be sacrificed and simplified. Although sound draughtsmanship should always be present, it is sometimes necessary to distort or exaggerate it to put across a point of interest or character. To express a feeling of vast expanse we can use our sketchbook in different formats.

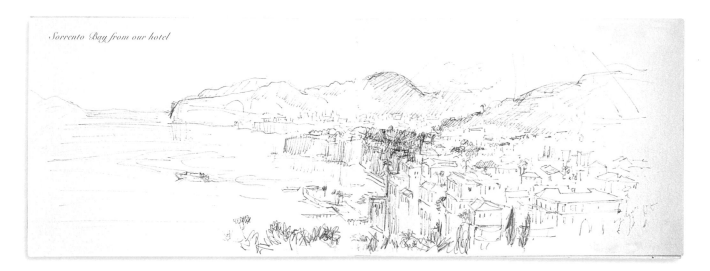

Sorrento Bay from our hotel

The wide vista of Sorrento Bay, with the unfolding views of the town and mountain, is enhanced by spreading it right across two pages of the sketchbook. The significant structure of this scene is the stepped collection of houses descending to the sea. These steps are emphasized by the dark tones of the trees and undulating sweeps of the mountains.

I used a burnt sienna water-soluble pencil for the initial sketch, then enhanced the tones with dense scribbles of sepia pen. The drama in this composition is enhanced by the pronounced platform of foliage against the paler, distant town buildings.

Here I used occasional small ink lines sparingly to create receding buildings whilst keeping the details for the foreground.

I painted the coloured sketch a few days later. The contrasts had lessened, but I still had to retain the feeling of sweeping distance, while being economic with both line and detail. Masking fluid highlights, which are small and diffused in the distance, get more precise and detailed as they come forward. Ribbons of gentle tones help to define the silhouettes of the distant mountains and the glassy sea. Bright colours in the foreground emphasize the roofs and trees.

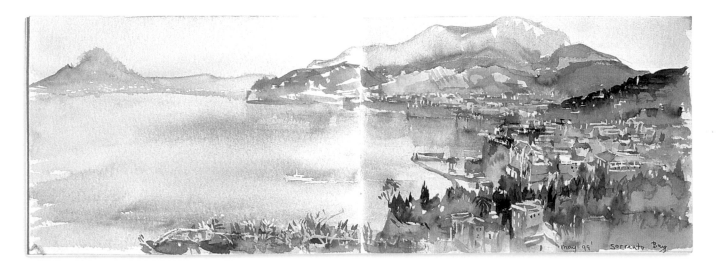

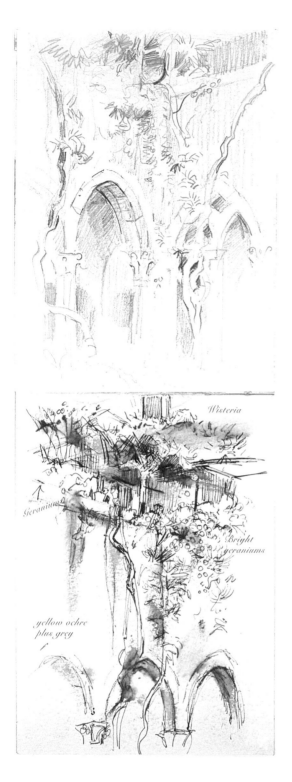

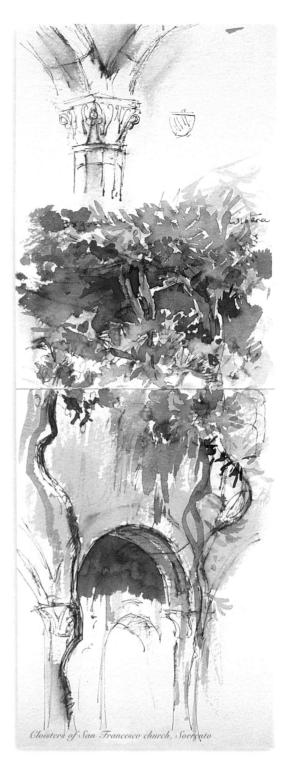

Wisteria

Geraniums

Bright geraniums

yellow ochre plus grey

Cloisters of San Francesco church, Sorrento

My sketchbooks are also used as diaries, with times of the day, and an accumulation of facts and dates amid my sketches, plus local maps from the information bureau – a must if you are depending on finding sights in a strange place! The beautiful Sorrento cloisters inspired a feeling of awe and majesty, whilst the tumbling flowers and plants added a personal touch, and softened the arches, pillars and balconies.

First, I sketched in my initial impression with an HB pencil emphasizing the varied arches and the contrasting greenery that adorned the facades.

Next, I focused upwards to the balconies, festooned with vines and geraniums. I used a sepia water-soluble art pen to quickly capture the wide range of textures that were now visible in the bright sunlight.

The final sketch was in watercolours. I just could not resist this array of rampant vibrancy alongside the rigid, but beautifully designed man-made arches now deep in shadow. The contrasts were exquisite!

Farmyard

This old farmyard, off a quiet lane in Cornwall, seemed deserted and abandoned when I first saw it several years ago. It was like stepping back a century or so! No one was around, so I climbed over the gate and started to take some photographs. Suddenly, the farmer arrived and caught me in the act. Luckily, he was rather amused and invited me to his other farmhouse in which he lived. We became friends, and he now has a painting of his farmyard, with his geese, on his living room wall. Unfortunately, the old buildings have been thoroughly modernised, but I have painted many pictures from the photographs I took that day.

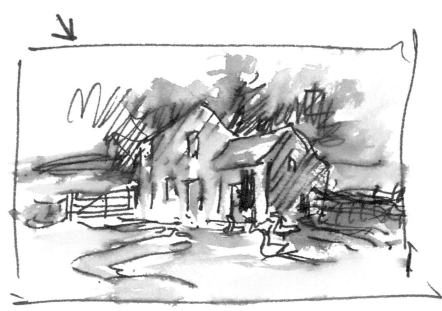

This sketch, worked up from the photographs below, shows the composition used for this demonstration.

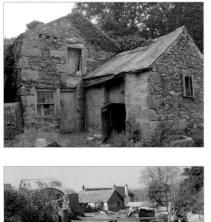

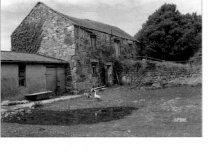

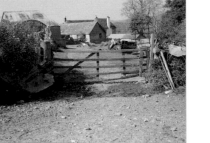

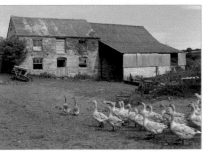

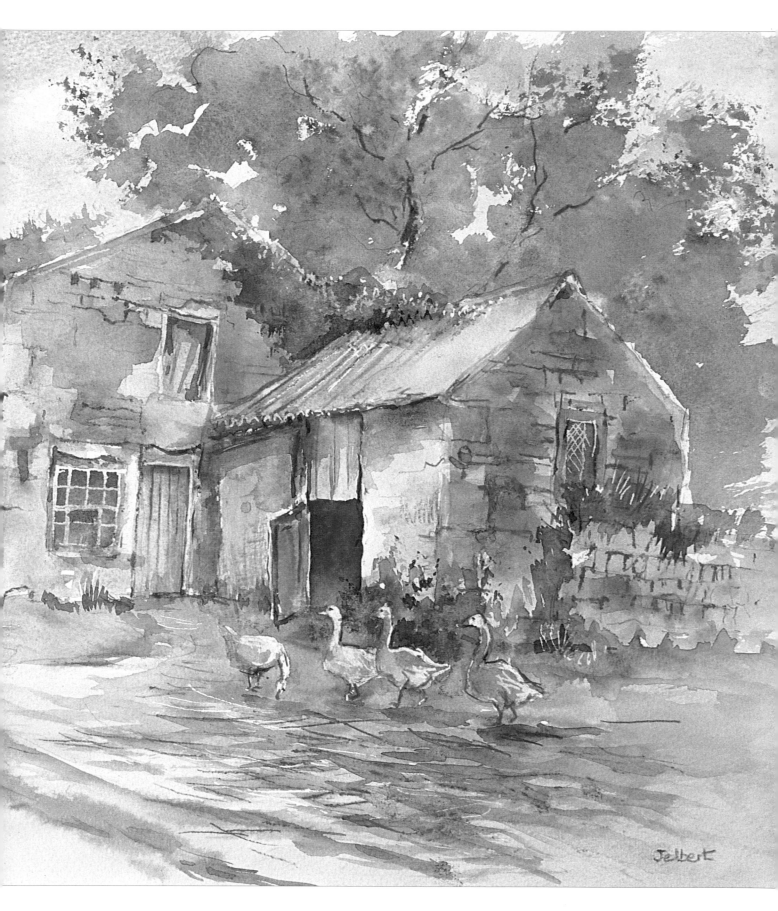

Jelbert

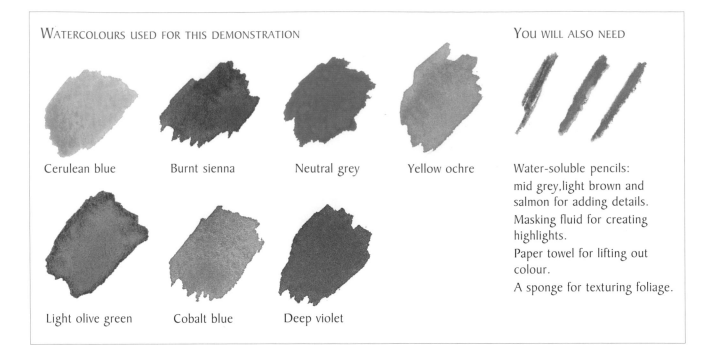

Cerulean blue

Burnt sienna

Neutral grey

Yellow ochre

Light olive green

Cobalt blue

Deep violet

Water-soluble pencils: mid grey, light brown and salmon for adding details.
Masking fluid for creating highlights.
Paper towel for lifting out colour.
A sponge for texturing foliage.

1 Use the photograph of the buildings to sketch the house, placing it correctly for this composition.

2 Use the photograph of the geese to draw a few geese in the foreground.

3 Now draw the wall on the right-hand side of the building.

4 Referring to the last photograph, draw in the gate.

5 Finally, add a few trees in the background and some marks to indicate the yard in the foreground.

6 Referring to the red marks on the sketch opposite, apply masking fluid to create highlights.

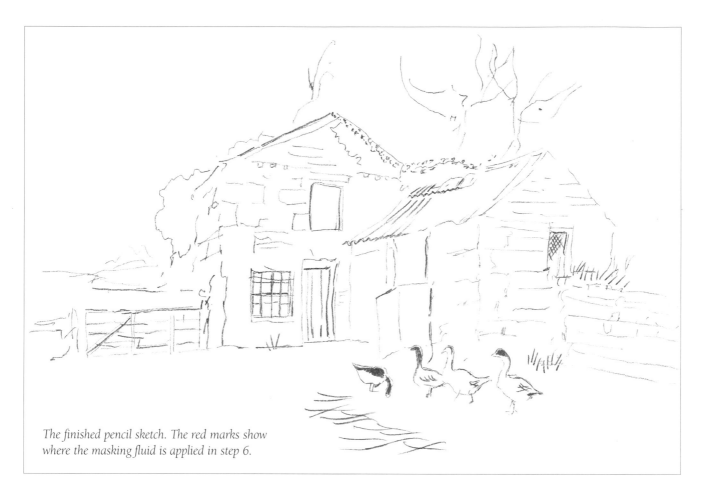

The finished pencil sketch. The red marks show where the masking fluid is applied in step 6.

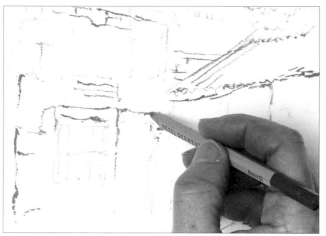

7 Use light brown and mid grey water-soluble pencils, dipped in water, to make marks on the stonework and roofs on the buildings . . .

8 . . . and the wall on the left-hand side.

Tip Erasing smudges

If you smudge the wet pencil marks, use a clean piece of paper towel to lift out most of the colour. What remains can be treated as 'added texture' in the final painting.

9 Use a salmon coloured water-soluble pencil to make random marks in the foreground, to define the ridge of the right-hand roof, and to define a few of the roof tiles. Use the mid grey pencil to make marks on the branches of the background trees.

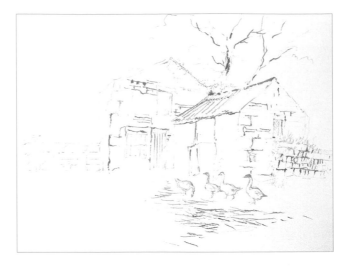

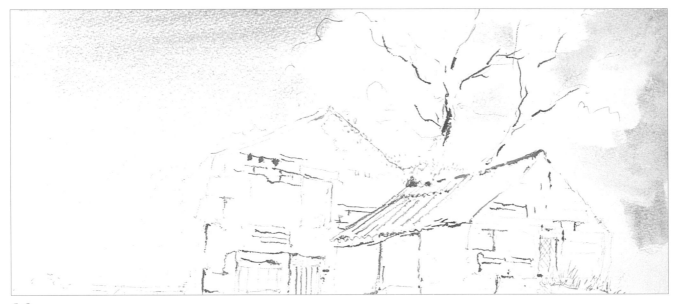

10 Wet the left- and right-hand areas of sky, and a few patches between the branches of the background trees, then lay in a wash of cerulean blue making the colour darker at the top. Soften the bottom edges with clean water.

11 While the colour is still wet, use clean pieces of paper towel to dab out indications of clouds.

12 Add a touch of burnt sienna to the cerulean blue, then paint a weak grey wash over the dabbed-out clouds. Use clean water to soften the top edges of these marks.

13 Use a cerulean blue wash and broad strokes to block in the doors and windows of the buildings. Note how some of the water-soluble pencil marks blend into this wet colour.

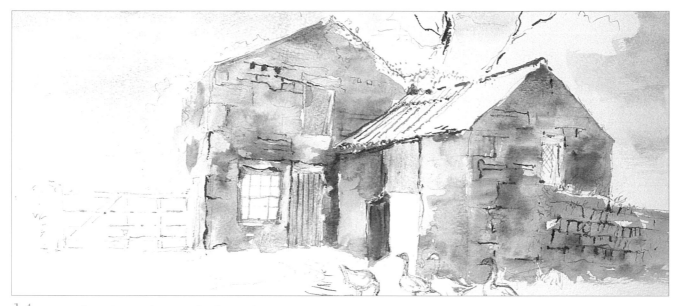

14 Use washes of neutral grey and yellow ochre, wet in wet, to block in the walls of the buildings. Vary the tones to reflect areas of light and dark, and the colours and textures of the stones. Leave to dry.

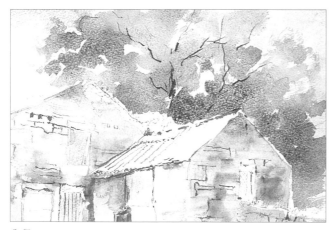

15 Mix light olive green with a touch of cobalt blue, then block in the foliage on the background trees, varying the tones to indicate light and dark areas. Add more blue to the mix then block in the foliage at the right-hand side of the building, leaving a white edge along the slope of the roof.

16 Use the different mixes on the palette and a sponge to add texture to the foliage. Note how these marks appear harder and sharper on the drier parts of the paper.

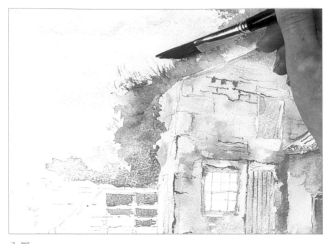

17 Use the same colour mixes to paint the foliage at the left-hand side of the building and behind the gate. Use a dry brush to 'feather' fine detail on the outer edges.

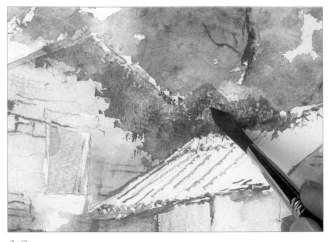

18 Use mixes of yellow ochre and cobalt blue to block in the ivy on the wall and roof of the building, dabbing the darker tones over the paler under-colours to create the texture of small leaves.

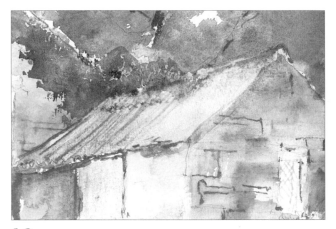

19 Block in the slope of the roof with neutral grey, allowing some of the salmon coloured pencil marks to bleed into it. Draw down some of the salmon colour from the ridge of the roof.

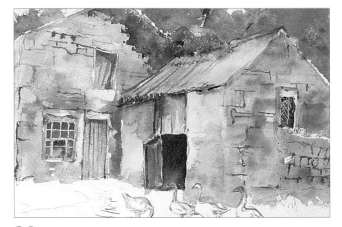

20 Mix deep violet with touches of burnt sienna and cobalt blue, then block in the dark shadows inside the open door, under the bottom edge of the roof, the panes of glass and the other shadows on the doorways.

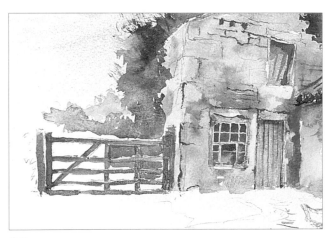

21 Add more burnt sienna to the mix, dilute it with water, then paint the gate. Use darker tones at the left-hand side (dark against light) and paler ones at the right-hand (light against dark).

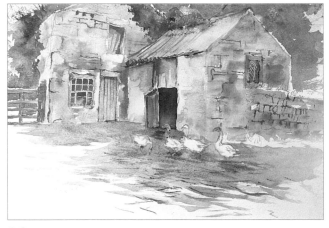

22 Use yellow ochre and burnt sienna to start blocking in the foreground, mixing the colours on the paper and cutting round the shape of the geese. Add touches of a very weak violet to create more texture. Work loose, random brush strokes on the outer edges of this patch of colour.

23 Use mixes of light olive green and cobalt blue to develop the greenery in front of the building, and up and across the top of the right-hand wall. Cut round the shapes of the geese, and make the tones darker behind them.

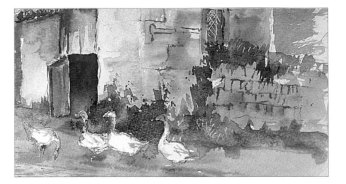

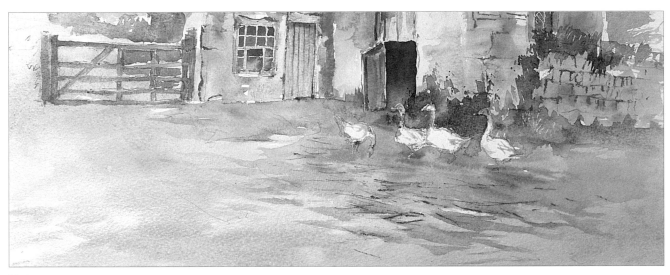

24 Use a weak wash of light olive green to block in the remaining white areas in the foreground and the white patches behind the gate.

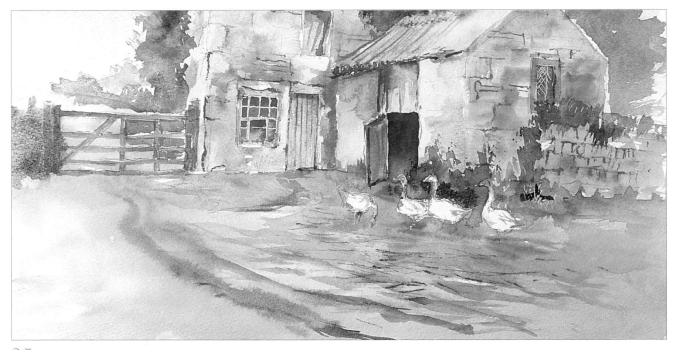

25 While the paper is still wet, mix a weak wash of burnt sienna with touches of deep violet, then paint in two long soft ridges of mud in the foreground, allowing these marks to blend and soften into the background colour. Add touches of this dark tone behind the geese to lift them away from the foliage behind. Add a touch of light olive green to the mix, then paint in an indication of foliage at the left-hand side of the gate.

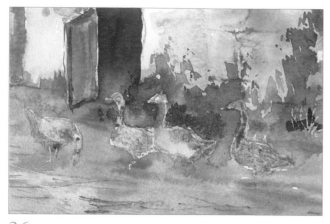

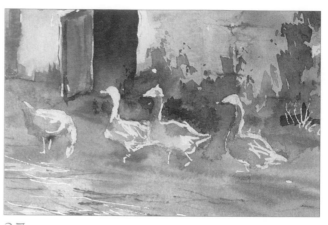

26 Use different mixes of deep violet and cobalt blue to block in the geese. Add touches of yellow ochre to the two geese at the right-hand side.

27 When the colours are completely dry, rub off the masking fluid from the geese . . .

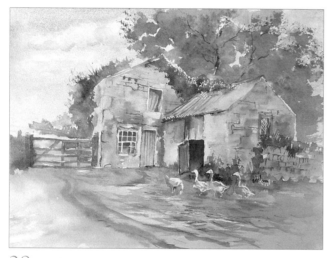

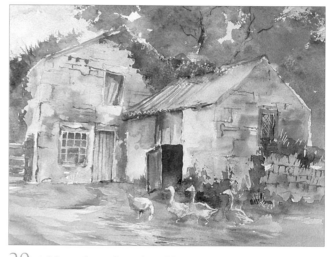

28 . . . then from the rest of the painting.

29 Add touches of cerulean blue to the geese, door and windows, the ivy and along the slope of the left-hand roof.

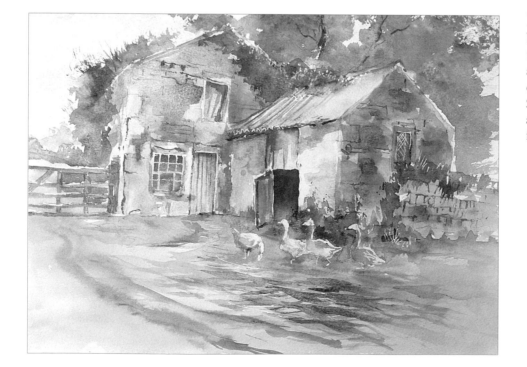

30 Prepare a weak wash of burnt sienna mixed with a touch of yellow ochre, then apply this as a glaze over parts of the walls of the buildings. Strengthen the mix, then add a few darker marks in the foreground, below the geese.

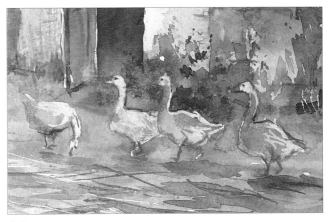

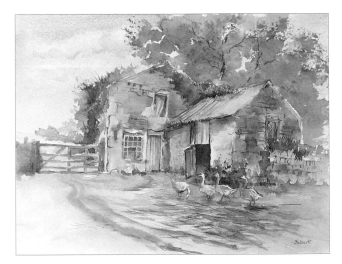

31 Finally, use the water-soluble pencils to define the shape of the geese and to add the finishing touch – the bright colour of their beaks.

The finished painting

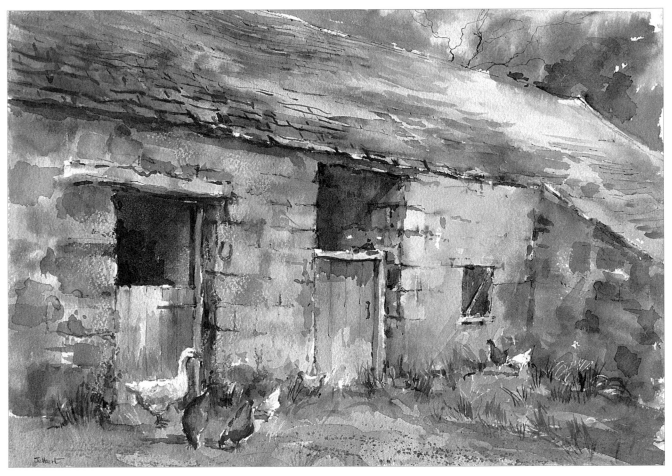

Peaceful Farmyard

Size: 355 x 255mm (14 x 10in)

I used the brightness of the left-hand door, the white of the goose's back and the dark shadows of the interior of the barn to form a good, strong focal point for this painting. I also echoed the burnt sienna colours of the chickens in the door hinges and horseshoe, to form exciting colour contrasts throughout this area.

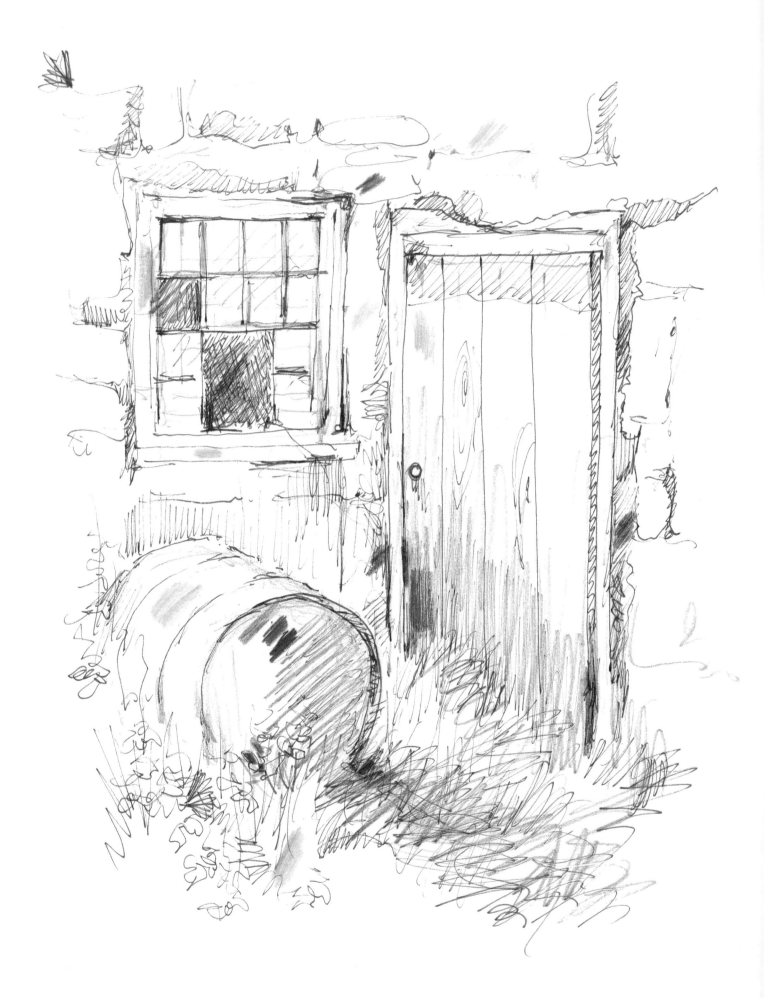

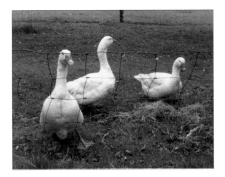

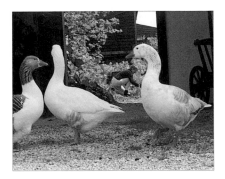

Farmyard Corner

The finished painting right shows another view of the farm buildings used for the step-by-step demonstration on pages 50–59. I painted it in my studio from the tonal sketch opposite and other reference material from my archives.

The tonal sketch, worked up with pencil and waterproof sepia ink, captured all the lovely textural surfaces of the stone walls, the grass, straw and weeds, the rusty container, the broken glass, and the old wooden door. I placed an arrow to remind me of the direction of the light source, and rather than adding handwritten notes, I used water-soluble pencils to scribble patches of colour in relevant places.

The geese and chickens, of course, wandered off before I got round to sketching them (this always happens), so I left them out, knowing that I had plenty of reference photographs.

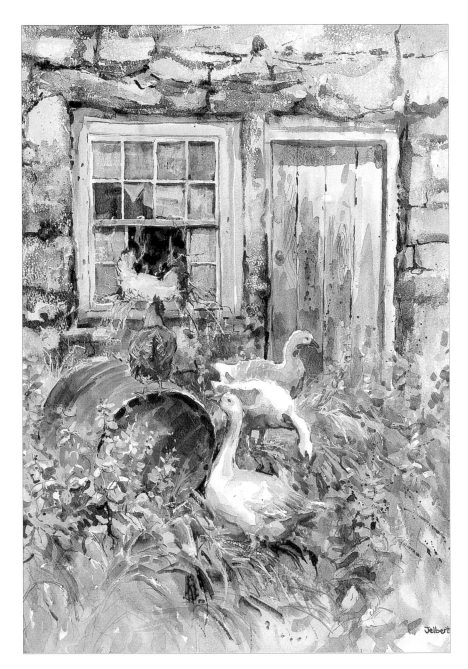

Sketching skills

Attempting to sketch and paint every detail in a scene is not the right approach, and is bound to lead to an overworked and rather stiff and photographic result! If you look at a subject through half-closed eyes, fine details disappear, and you are left with simple shapes of colour and tone; the building blocks of good paintings. So, look closely at the subject, simplify the textures or objects you see, and try to balance the different tonal areas within the composition. You may need to move things about, demolish a building, sink a boat or add a figure to achieve a good composition! This may take several attempts – do not be put off by this, it is what sketching is all about – determination will succeed!

SIMPLIFYING SCENES

On these pages are a few examples showing how to simplify a composition. The photographs have been included so that you can compare the scene that was in front of me with my pencil sketches, but, of course, these are not to hand when you are sketching *in situ*.

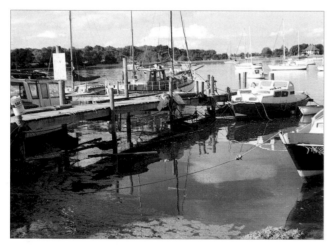

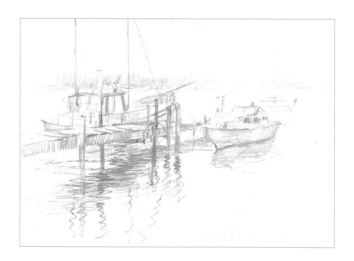

Del Quay, Chichester

This delightful working quay is a magnet for painters and I take students there every year. The photograph is very busy and a simplified composition is definitely needed here. It is, however, a good example of counterchange – light against dark, warm colours against cool ones. For example, the warm brown colours of the boat behind the pontoon and its reflection are light and bright and contrast well with the cool dark colours of the reflections of the pontoon and the dark hull of the small boat at

the end of the pontoon. Note also how the tone of the vertical posts changes from top to bottom depending on what is happening in the background. In the pencil sketch, I decided to leave out distracting details at both the left- and right-hand sides of the photograph. The house on the distant, wooded horizon plays no part in the composition, so I left it out. I also removed most of the small boats in the distance to leave a calm flat space behind the two boats moored to the pontoon, which accentuates their shapes.

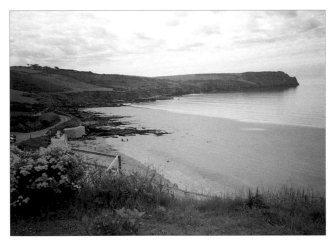

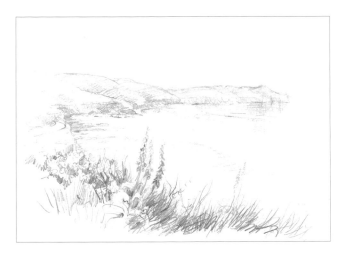

Cornish Cove

In this typical photograph of a coastal scene, the tones on both the distant hills are too similar and the individual shapes of the cliffs and fields are not clear. The road and beach details lack interest and the wooden rails in the foreground distract the eye. The angular shape of the beach is good, but lighter, brighter colours would make it better. The overall composition is too horizontal and would be improved with some vertical elements.

When composing the pencil sketch, I decided to make the foreground more dominant by adding extra detail, including some spiky foxgloves to lift the eye up into the picture. I removed the wooden rails and simplified the road and beach details. The distant headland has also been simplified to create fewer, but more definable shapes with good tonal contrast.

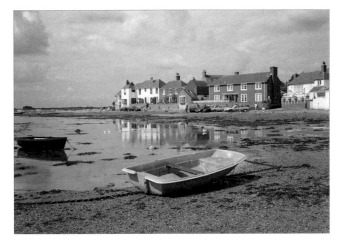

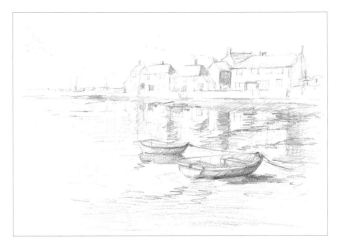

Bosham Harbour, Sussex

This photograph has lots of interest, but it lacks a single focal point. The buildings and their reflections form good shapes that lead the eye across to a point on the horizon, but the eye is distracted by the positions of the foreground boats which look uninspiring and boring. In the pencil sketch, the background buildings and their reflections have been retained, but all the cars

and figures in front of them have been removed. The shape of the boat in the foreground has been made more interesting and the position of the other boat has been changed. Now, their combined, triangular shape leads the eye to the same point as that of the buildings. This focal point (which is rather indefinable in the photograph) has been emphasized by the addition of a small boat.

INTRODUCING FIGURES

Human figures have been a subject of paintings ever since painting began. Some pictures tell you about events, others about people. Figures in a scene provide a fresh element in your work, and often form a natural focal point. Build up confidence by drawing yourself – just prop up a mirror and sketch yourself in different poses and at various angles. Then, try sketching a friend sitting by a fire, at a table, sketching or reading. Do not try to capture movement at this stage or you will be deterred from ever trying again! When you have gained confidence in sketching a single figure, try working with a group.

Figures in a landscape make a considerable impact, but you must consider their scale, position and groupings. They must harmonise with the rest of the picture, and become part of it.

Get into the habit of using your sketchbook on the spur of the moment. It will improve your figures, and your sketches, no matter how rough they may be, are a record of ideas for future work. The pose, the colours or effects of light can then be developed in later sketches. You can always ask a friend to model for you so that you can recreate a more detailed pose.

These sketches show some of my students in various poses. They were sketched with water-soluble pencils and both waterproof and non-waterproof inks.

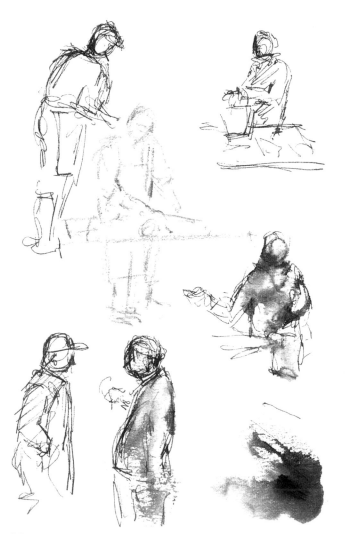

I work up match-stick-man sketches to construct the pose and proportions. Proportions do matter and must be checked – hold your pencil at arm's length to assess the relative proportions of head to body length, and legs and arms. Check that these agree with your drawing. Reassess your proportions every so often. Consider the composition around the figure, remembering that figures move and you have only a short time to act!

TIP USEFUL PROPORTIONS

Eyes are halfway down a face, the nose halfway between eyes and mouth, the mouth halfway between nose and chin, and ears extend from the top of eyes to the bottom of the nose. The hairline gives the character of the person. The neck must be thick enough to support the head. Shoulders slope downwards.

An adult man is roughly 7–8 heads high, a woman 7 heads, a child 5 heads and a toddler 3–5 heads.

A body can be divided into three roughly-equal sections. Arms are quite long, and extend to halfway down the thigh.

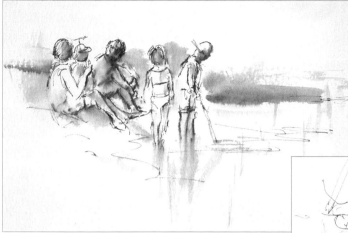

When sketching groups, try to visualise the shape of the whole mass of figures, not individual shapes.

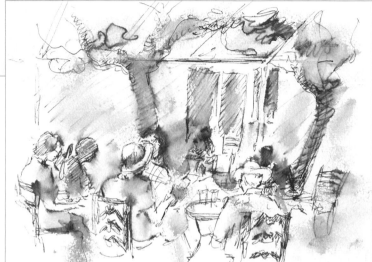

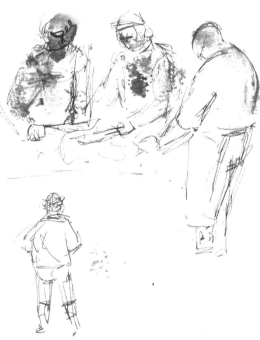

Sometimes, you need a counterchange of tone within a group of figures to convey depth and perspective. Note how the man at the bottom right stands out against the dark tones behind him. The lady (left of centre) is sketched with the same tones as the background tree, but she is set against paler tones used to depict another man in front of her.

All the studies above were quick and spontaneous sketches. Speed is essential, especially when trying to capture natural poses, and you must learn to memorise the shapes you first see. More often than not, when you glance up from your sketch the pose you are sketching will have completely altered and, sometimes, the 'models' will have even disappeared!

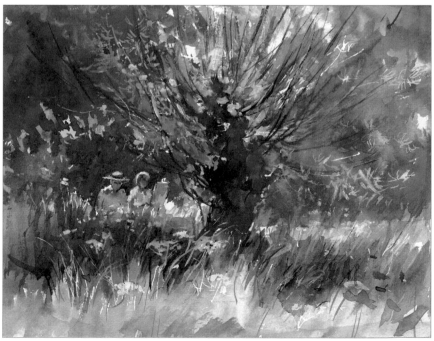

Painting for Pleasure

The figures in this painting are small and half hidden in the foliage. They are, however, bathed in sunlight and the light colours stand out sharply against the shaded background.

Quite often I come across a scene in which I would like to place a figure. On other occasions there are figures, but they are in the wrong place. This is the time to thumb through your sketchbook to find a suitable figure. I had to do this for the finished painting opposite which I painted in my studio. It is based on a sketch made *in situ* a few years ago. There are three figures in the sketch, but I wanted just one dominant figure to act as a focal point. I flipped through my sketchbooks and found a photograph of a man in just the right pose and in proportion to the scale of the sketch. I traced him, then moved him around to find the best position before transferring him on to the sketch.

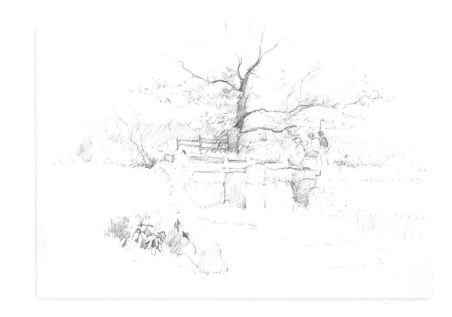

The original sketch and one of my reference photographs used as the starting point for the finished painting opposite.

Tip Transferring images

There are several ways of placing extra images in a composition. Using thumbnail sketches, tracing figures then placing them on your sketch, so you can see your scene through the tracing paper. You could cut out individual shapes and place them at various points to find where they look most at ease, or make a pencil image on tracing paper and move this about until you are happy with a position.

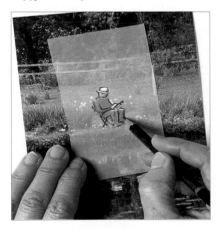

Make a tracing of the figure.

Move the image around the sketch to find the best position.

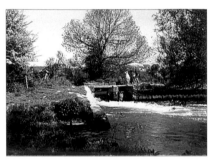

Transfer the image on to the sketch.

Shawford River

After trying several positions, I decided to place my new figure on the left-hand riverbank. He is sketching something in the water, on the other side of the river!

The tree was too central for a good composition, so I decided to move it slightly to the right.

I left the three figures with the umbrella in the modified sketch (for future reference), but omitted them in the final painting. I also left out the fence posts because they distracted my eye.

In my sketch, the foreground is rather stark and ugly, so I decided to embellish it with some spiky grasses and weeds.

I was teaching students when I made the original sketch, and did not have time to make colour notes, but my photographs helped me with the colours.

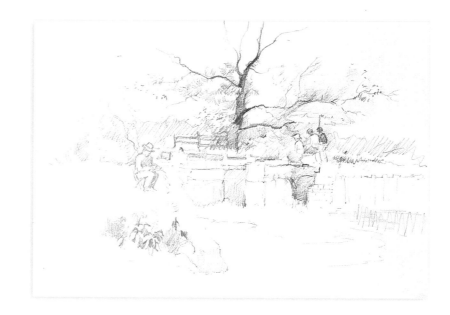

The modified sketch and, below, the finished painting.

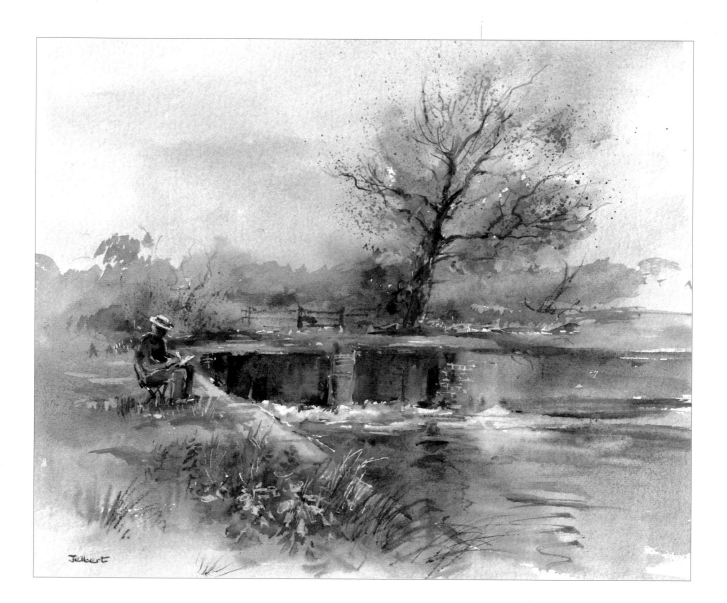

Quiet harbour

I love painting coastal scenes, so it was quite natural to choose one for this step-by-step demonstration. I have used the photograph for many finished paintings as it offers so many solutions. The sketch below, worked up in water-soluble pencils, is a simplified version of the photograph. The eye is carried down the steps at the left-hand side of the composition, then up into the flotilla of boats bobbing on the sea. The arrangement of the boats in the photograph seemed to be a bit of a muddle, so I left some of them out of the sketch to leave two groups, both of which have an interesting shape.

I emphasized the reflection detail to make the surface of the sea more alive and dramatic. The rigging and clutter on the boats was far too detailed, but some of it had to be included. I simplified this by using fine, dashed lines of masking fluid. For added texture in the reflections, I also used a candle as a wax resist.

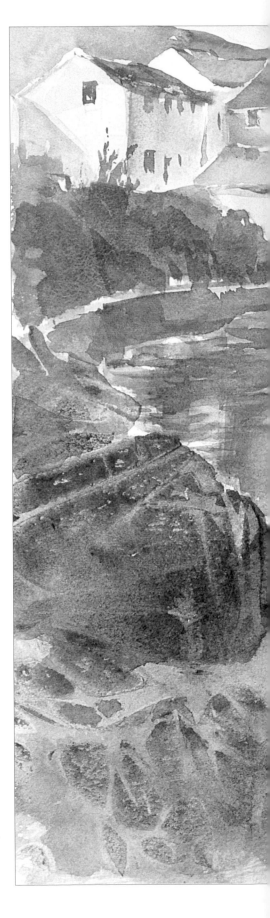

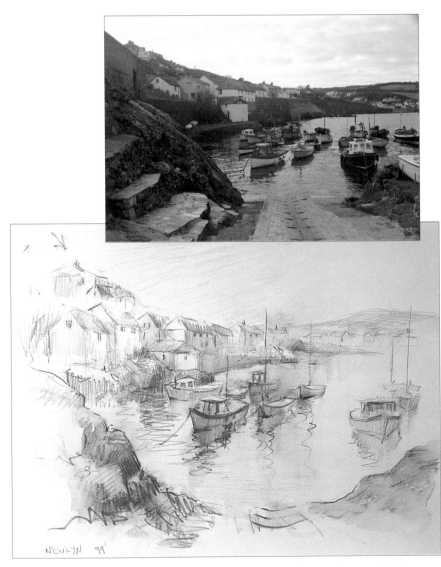

I used this water-soluble pencil sketch, worked up from the reference photograph above, as the inspiration for this demonstration.

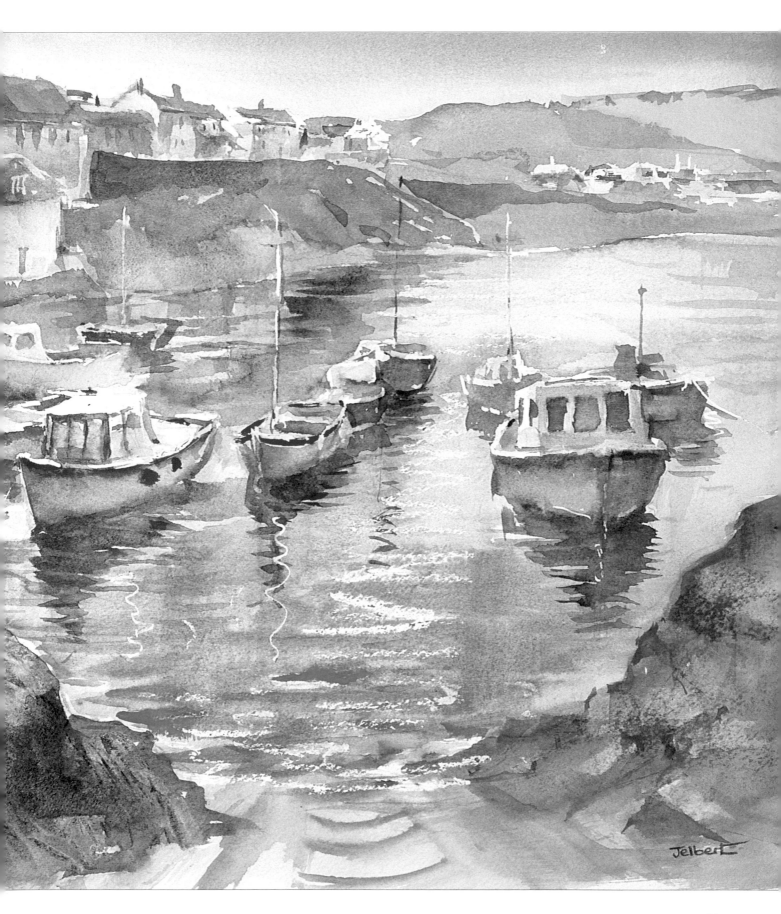

WATERCOLOURS USED FOR THIS DEMONSTRATION

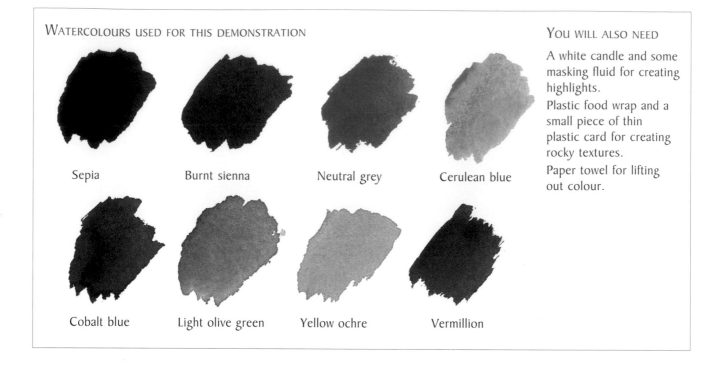

Sepia

Burnt sienna

Neutral grey

Cerulean blue

Cobalt blue

Light olive green

Yellow ochre

Vermillion

YOU WILL ALSO NEED

A white candle and some masking fluid for creating highlights.
Plastic food wrap and a small piece of thin plastic card for creating rocky textures.
Paper towel for lifting out colour.

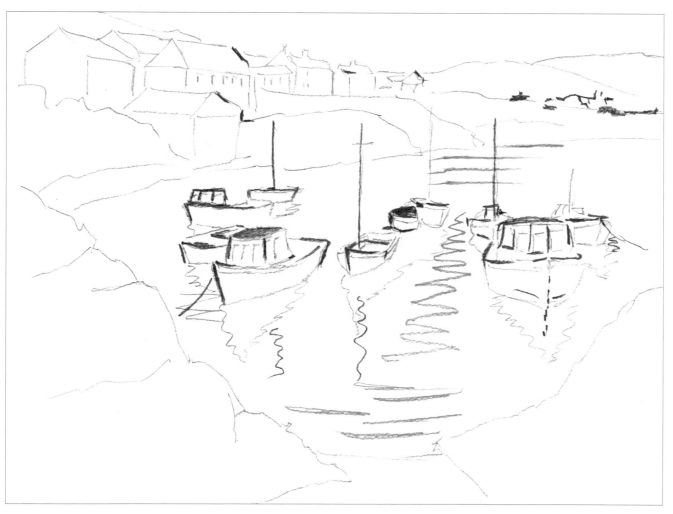

Pencil sketch of the final composition. The green marks show the marks made with the candle in step 1. The red marks denote the application of masking fluid in step 2.

70

1 Transfer outlines of composition on to watercolour paper, then use a candle to make marks on the paper that will eventually create texture in the highlights. These marks are shown in green on the sketch opposite.

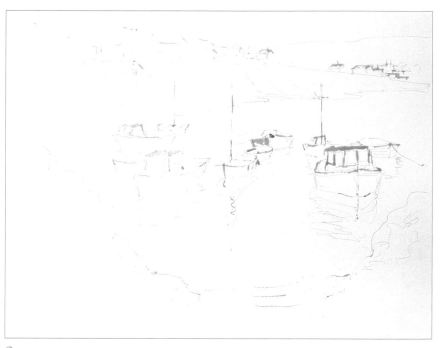

2 Use masking fluid and a pen to draw in the highlights on the boats, houses and distant headland. These marks are shown in red on the sketch opposite.

3 Mix sepia with burnt sienna, then block in the foreground rocks on the left-hand side.

4 Place a piece of plastic food wrap on the wet paint, scrunching it up slightly to move the paint around.

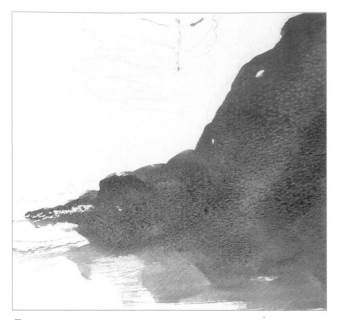 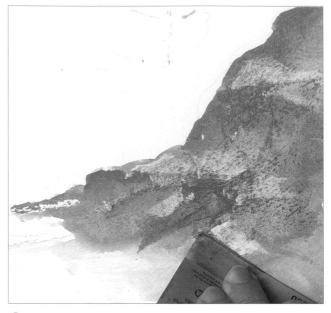

5 Block in the right-hand rocks with neutral grey, lay in touches of burnt sienna, wet into wet, . . .

6 . . . then drag and slide a piece of thin stiff plastic (an old credit card is ideal) through the wet paint to create highlights and darker shapes.

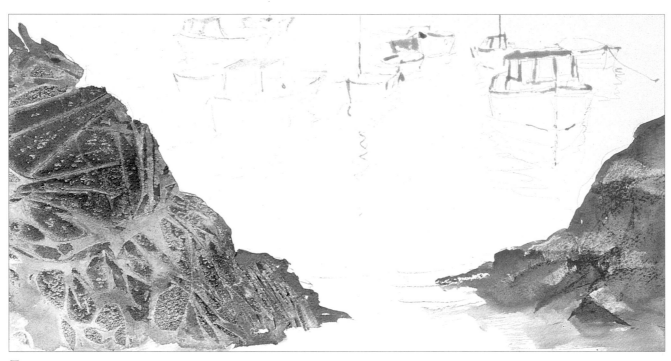

7 Remove the plastic food wrap from the left-hand rocks and leave the colours to dry thoroughly.

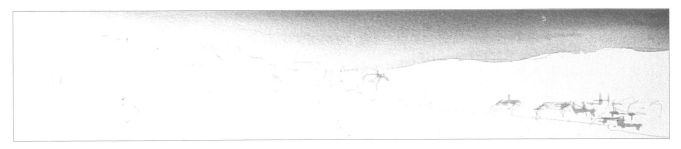

8 Wet the sky, then lay in a band of cobalt blue. Start at the right-hand side and weaken the wash as you work across the paper.

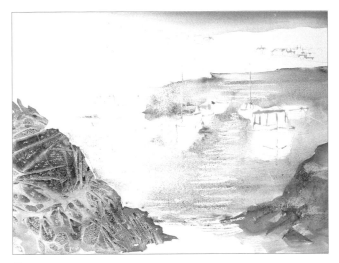

9 Wet the sea, lay in a wash of cobalt blue; work from the top right-hand corner and bring the wash down and across the paper. Note the effect of the marks made by the candle.

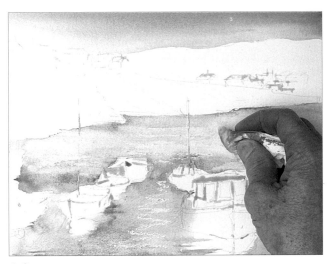

10 While the wash is still wet, lift out a band of colour in the distant water by dragging a clean piece of paper towel horizontally across the paper . . .

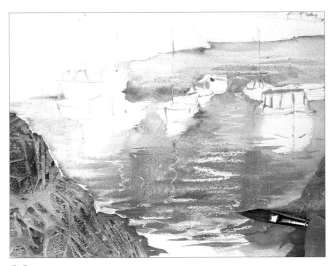

11 . . . lay in horizontal bands of cerulean blue, wet into wet, in the foreground, then drag the brush downwards through the horizontal strokes . . .

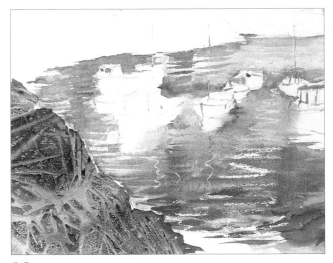

12 . . . then, still working wet in wet, add touches of a weak sepia wash to form the base layer of rippled reflections.

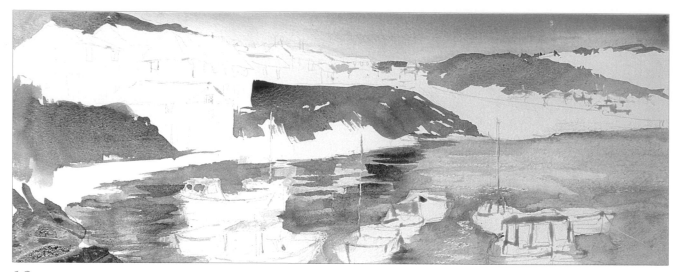

13 Use various mixes of cobalt blue and light olive green to block in the middle distant foliage and rocks. Lay bands of these colours into the ripples. Weaken the mixes and lay in the far distant hills.

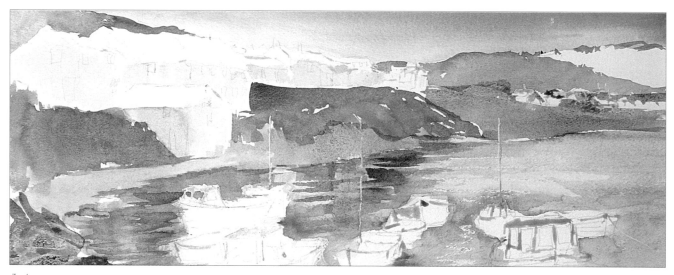

14 Use an even weaker wash of same colours to block in the walls of the middle distant buildings. Use burnt sienna to block in the edge of the harbour, the roofs of the small distant buildings and the ground in front of these buildings. Again, lay bands of this colour into the rippled reflections.

15 Block in the far distant field with a weak wash of light olive green. Add touches of yellow ochre here and there in the middle distance.

16 Use yellow ochre to block in the foreground slipway, taking some of this colour up into the water. Use neutral grey to define the shape and shadows in the slipway.

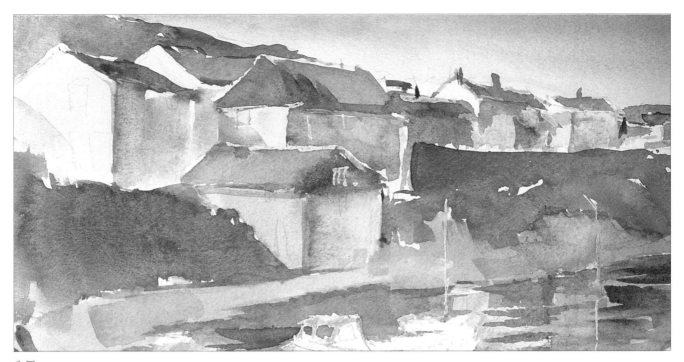

17 Mix burnt sienna with a touch of cobalt blue, then block in the roof shapes. Vary the colour from roof to roof, and weaken the tone as the roofs recede into the distance. Mix cobalt blue with a touch of burnt sienna, then block in the walls of these buildings – again vary the colour and tone. Add touches of cerulean blue here and there.

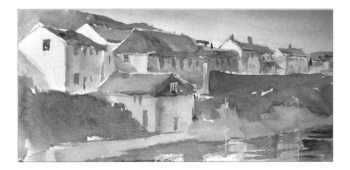

18 Mix burnt sienna with a touch of cobalt blue, then paint in the doors and windows. Vary the colours and make the window sizes smaller and closer together on the more distant houses. Use the same colours to define shadows under the eaves.

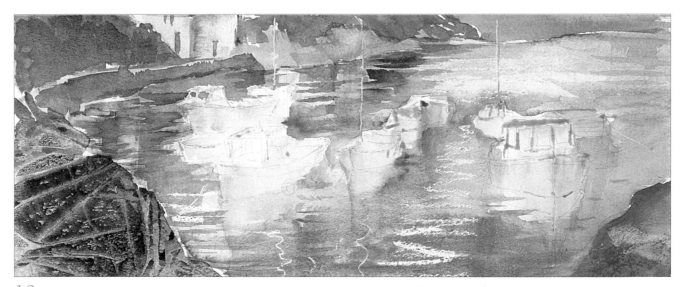

19 Darken the breakwater with a glaze of cobalt blue mixed with a touch of burnt sienna. Darken the left-hand foliage with a deeper glaze of light olive green. Wash over the boats and their reflections with yellow ochre to give them an underlying warmth.

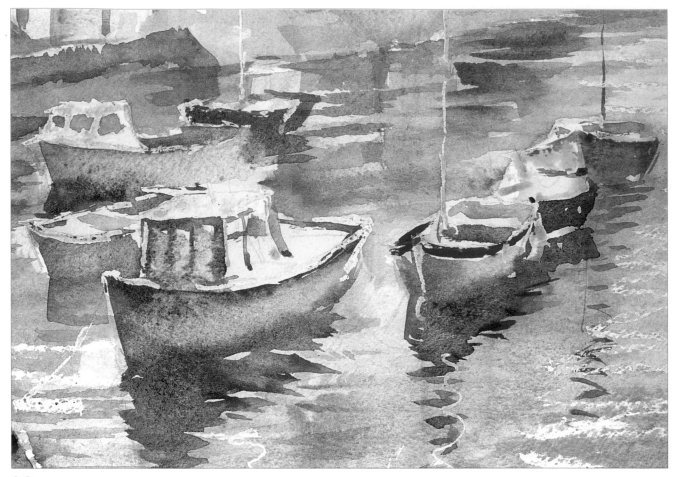

20 Paint the left-hand group of boats, which form the focal point of the composition, with a variety of colours worked wet in wet and wet on dry. I used light olive green, cobalt blue, vermillion, cerulean blue, sepia and burnt sienna. Use the same colours to create the rippled reflections.

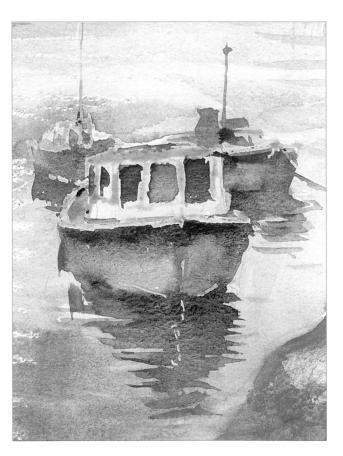

21 Now work the right-hand group of boats, using more muted colours than those used for the other group. Use cobalt blue and cerulean blue, mixed on the paper, for the basic shapes, and sepia for darker shadows and ripples. Leave to dry.

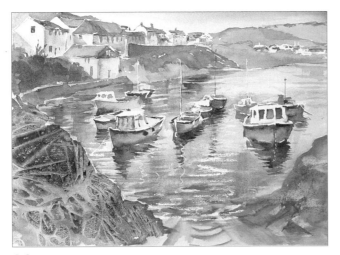

22 Remove all masking fluid.

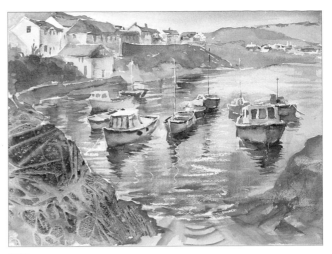

23 Mute some of the exposed white paper with weak washes of yellow ochre and cerulean blue.

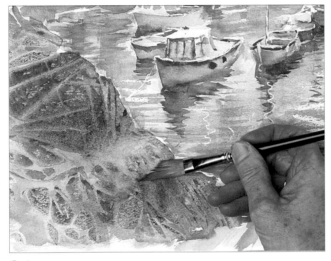

24 Use clean water to wet a 'ledge' in the left-hand rocks. Dry the brush then lift out the colour from this area to highlight the ledge.

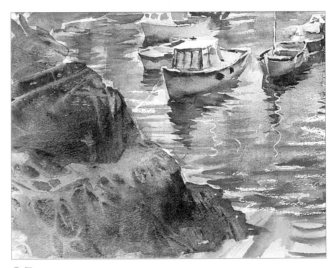

25 Wet other parts of the left-hand rocks then scrub over these to soften some of the marks made with the plastic food wrap. Introduce sepia to define shadows and shape.

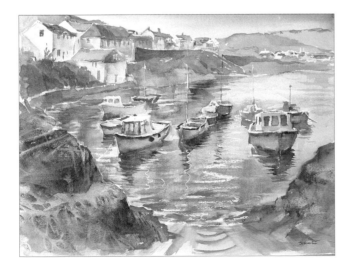

The finished painting. Having looked at the image at the end of step 25, I decided to improve the contrast by adding some deeper shadows here and there.

TIDELINE TREASURES

Coastal scenes are another of my favourite subjects, and I take every opportunity to make as many sketches as possible. Here are a few doodles from some of my sketchbooks.

These three colour sketches show the same boat at different levels of the tide. Each could bring character and beauty to a future masterpiece.

I sketched these quick sepia ink scribbles as I glanced along the shoreline. At the time I did not have a painting in mind, but I am always on the lookout for details such as these. One of them could be very useful later on.

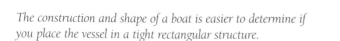

A lovely reflection. Reflections are best when the image is wiggly in the water and is equal in length or longer than the object it is mirroring.

The construction and shape of a boat is easier to determine if you place the vessel in a tight rectangular structure.

78

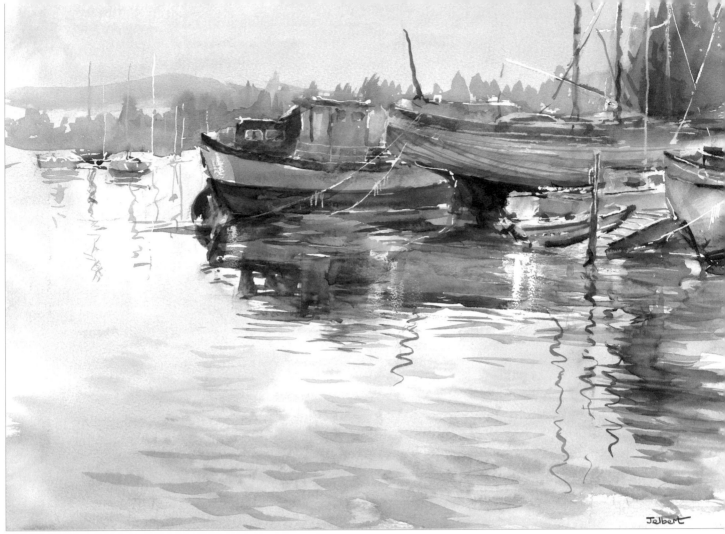

Reflections at Del Quay

Size: 405 x 305mm (16 x 12in)

This finished painting contains many of the sketchbook observations shown on the opposite page.

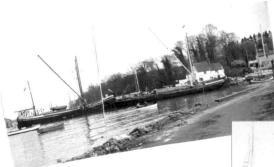

Pin Mill, Suffolk

I have used my photographs and sketches of this fascinating place to create many paintings. I took lots of photographs from a variety of angles – including panoramic views, close-ups, and middle-distance studies. I had so much reference material, I just could not fail when using them to compose a picture!

I joined two photographs for this close-up composition of old dark barges set against the bright white building in the distance. I used a 4B pencil to obtain the varied and dramatic tonal content of this scene. It has everything: buildings, reflections, characterful boats, and both horizontal and vertical interest.

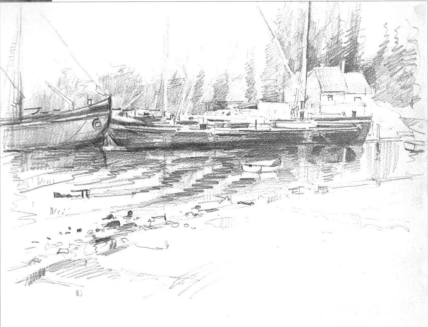

Using photographs

All my sketchbooks bulge with reference photographs that complement my sketches. Photographs, of course, are full of detail, much of which is often irrelevant to a composition, and you should take care to select only the information that you need for a successful painting.

A good mixture of photographs, sketches and colour notes will provide all the information you need for fruitful painting. By developing these elements you build a solid foundation from which other options and ideas will spring later on. Never rely solely on your memory – it plays tricks – so do not leave any blank spaces in your sketchbook. A photograph does not solve every problem, but it does remind you what was there in the first place!

LANGSTON MILL

This two-page spread from one of my sketchbooks shows how I link reference photographs with a sketch. For clarity, I have removed the staples holding the photograph on the far side, and moved it to show all of the pencil sketch. The photographs, taken from different viewpoints, contain all the detailed information I might need in the future. Together, the images cover quite a wide area of the scene and include lots of details around the mill itself. Although the seascape is less important than the mill, it can still form an integral part of any composition.

Photographs, of course, have to be processed, so making sketches of the scene *in situ*, and adding colours notes, etc., is more important. Remember that the purpose of a sketch is to spark your imagination at a future date. It must therefore contain sufficient information for you to relive the time spent on site.

The mill is a rather complex shape, so my pencil sketch concentrates on its structure and how it fits into the shapes around it. Although the buildings are the focal point of this composition, I decided to make a feature of the metal gate in the foreground. This automatically pushes the buildings back into the middle distance giving interest and a feeling of space to the muddy and empty sea plain. Here, although devoid of water, the flat surface reflected colours in superb abstract shapes. Even though it was mud, the colours – burnt sienna, olive green, yellow ochre and a host of blues – were gorgeous.

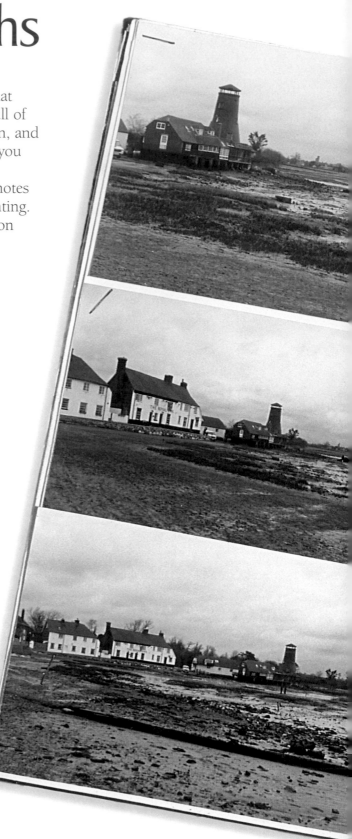

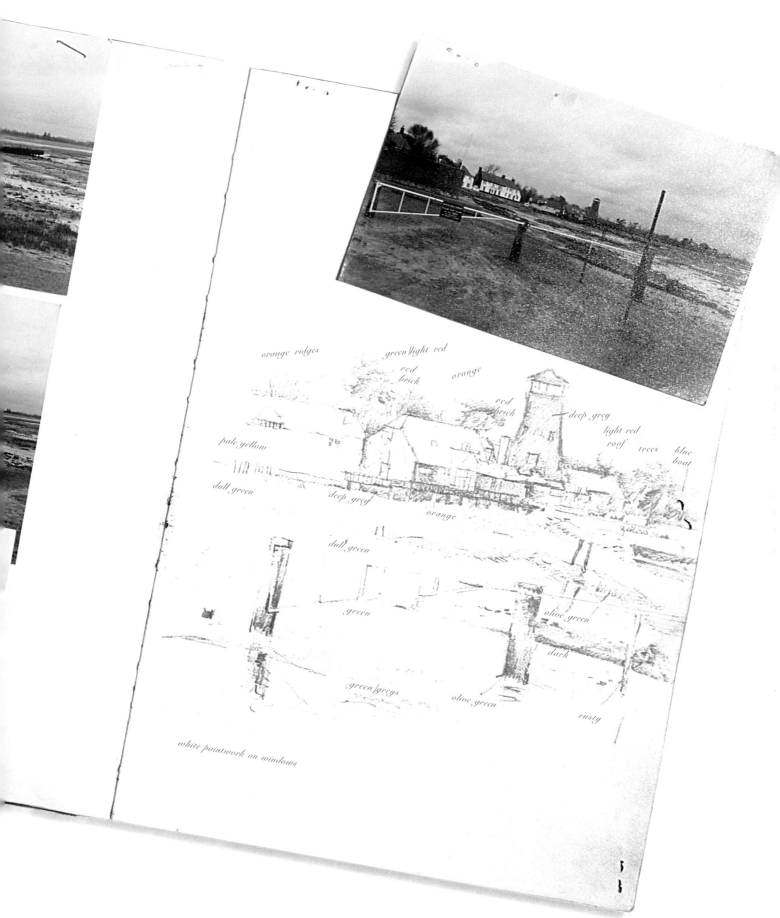

orange ridges green/light red

red
brick orange

red
brick deep grey

light red
roof trees blue
boat

pale yellow

dull green deep grey

orange

dull green

green

olive green

dark

green/greys olive green rusty

white paintwork on windows

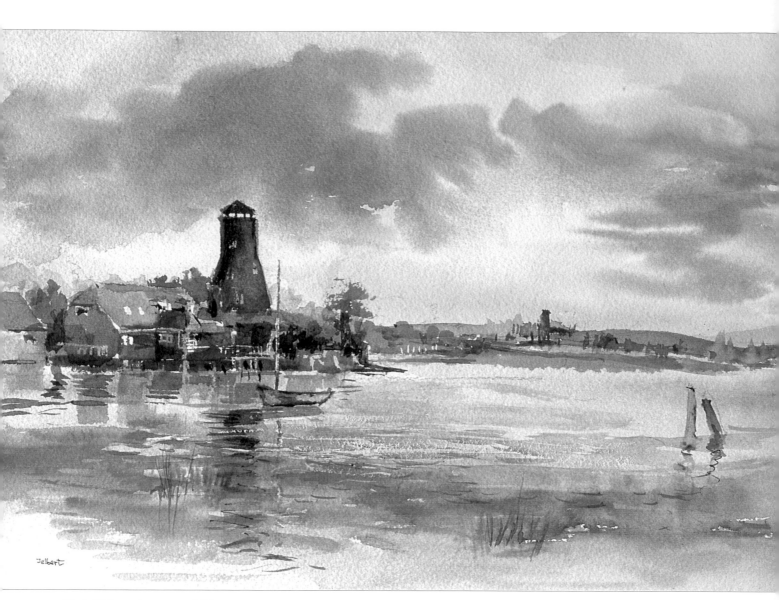

High Tide at Langston Mill

Size: 330 x 240mm (13 x 9½in)

I used the reference photographs and sketch on the previous pages to select key points about the accuracy of the mill for this finished painting. The mill is not the most attractive of buildings, so I decided to include another element to counteract this. I added a dramatic sky and reflected its colours on the surface of the water at high tide. The water sweeps around the mill highlighting other features within the composition. I also softened the contrast slightly and added some gentle colours to the dark shape of the mill.

TIP FILING PHOTOGRAPHS

Just to be safe, I often take too many photographs of a particular scene, but I never throw away anything other than abject failures. I select the most relevant and add these to my sketchbook. The others I file in a set of named boxes and files; seascapes, skies, buildings, gardens, flowers, cityscapes, etc. On a smaller scale, you could use an indexed concertina file available from most stationers.

Digital cameras are very useful. Their images can be stored on discs, which take up far less room than boxes, and they can also be enlarged on a computer when required.

I am old fashioned, however, and I just love mulling over and touching original photos. But, eventually, I am sure I will succumb to modern technology and become computerised and digital.

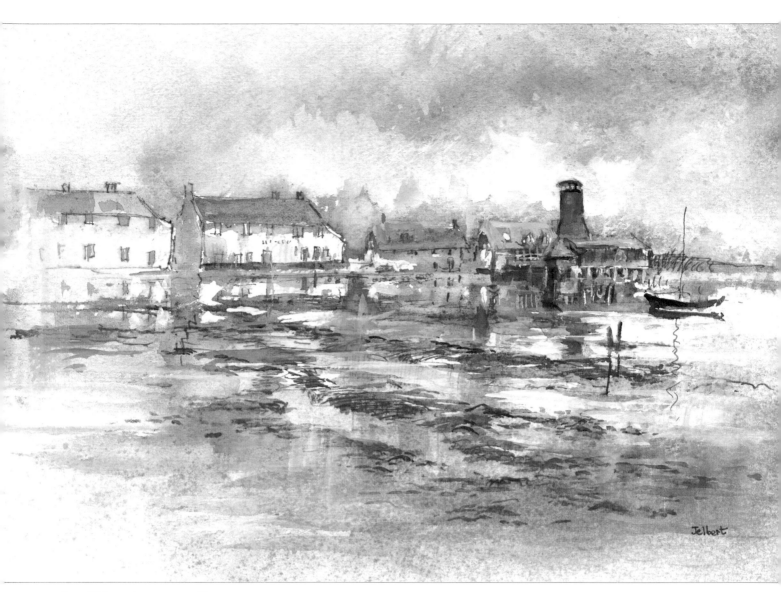

Low Tide at Langston mill

Size: 330 x 240mm (13¼ x 9½in)

For this finished painting of the mill, I decided to retain the fascinating assorted shapes between the seaweed and mud banks. Some poles, sticking up at random from the flats, nudge the centre of interest towards the mill. The banks of seaweed circle expansively towards the mill, starting from the stony foreground and coiling towards the other buildings on the quay. These shapes also pull the eye in a clockwise motion towards the focal point. I enhanced the sky and its reflection on the surface of the water in the harbour with cobalt blue, giving more depth and colour to the composition. The reference photographs proved invaluable, as they include details of the public house and other buildings that I had not drawn in the original pencil sketch.

Foxgloves

Surprisingly, I came across this typical English scene on a painting holiday in Brittany, France. It was late in the afternoon and I had to work quickly to get the reference material together. Before the light faded too much, I took a series of photographs, some of which are shown here.

I filled a page of my sketchbook with quick pencil scribbles of the different flowers, leaves and seed heads of the campions, ferns and foxgloves in the hedgerow.

Then, using a violet water-soluble pencil, I sketched the two compositions shown opposite. The top one was sketched from the same position as the bottom-left photograph on this page. The other sketch is a view from the same spot but in the opposite direction. Both sketches have an arrow to denote the direction of light source (the sun). This is an important reference when it comes to adding shadows and highlights on a finished painting.

I kept shapes very simple and very basic, especially in the background. I annotated both sketches with useful hints about the colours and plants I could see – an important backup to the photographs.

If you do not have a digital camera and colour printer, you have to wait until the film is printed before you know whether the prints convey the correct colouring, tones and details! The greens in the set of pictures above were a little bright, but I was pleased with the results.

Sometimes, I get an enlarged photocopy of a particular part of a photograph but, mostly, I use a small magnifying glass to study prints in more detail.

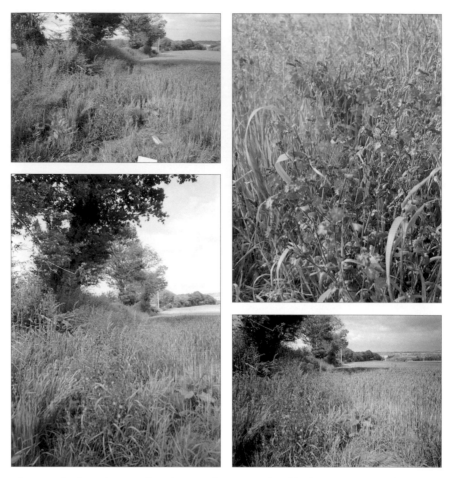

These are the four photographs I chose to place in my sketchbook to complement the sketches on this page. Notice that I took both landscape and portrait formats.

The close-up of the pink campions gives a fantastic contrast in both colour and texture to the background of grassy undergrowth. The three normal shots provide details of the dark, dominant tree and include information about the pattern of yellow ochre and light greens in the middle distance, and the blues in the distant, undulating hills.

Quick pencil sketches of flowers, leaves and seed heads can be a very useful source of reference.

TIP CHECKING DETAIL

Nature books are excellent for checking details. I have built up a real treasure trove of second-hand books that I find in charity shops, markets and fairs!

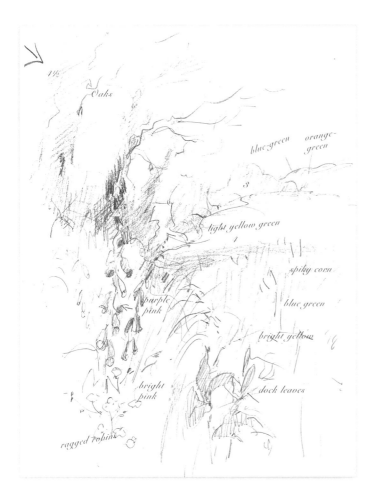

The labels on the top sketch, approximately:

Oaks
blue-green orange-green
3
light yellow green
spiky corn
purple pink
blue green
bright yellow
bright pink
dock leaves
ragged robins

I used this composition for the painting on page 86. Note the use of tonal numbers (see page 24). The sketch below, made from the same spot, but in the other direction along the hedgerow, also provided useful information for the finished painting.

TIP TAKING USEFUL PHOTOGRAPHS

Try to take photographs at different times of the day. Mornings and evenings are the best times. Avoid very bright sunlight. A strong light source results in deep shadows which can black out the details within the shadow. Photographs without any direct sunlight will give you depth and detail without the drama – a good foundation on which to place your shadow shape.

Take close-ups of details as well as more general shots of the landscape. Include portrait formats as well as landscape ones; the tall, portrait format can often be used to good effect in landscape paintings. The finished painting on page 86 is a good example.

A useful code to remember is that the brighter the sunshine, the deeper the shadows will be.

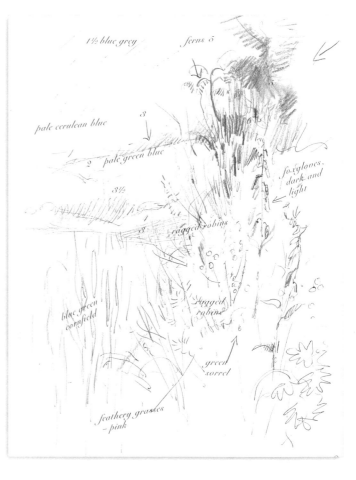

The labels on the bottom sketch, approximately:

1½ blue grey ferns 5
pale cerulean blue
3
2 pale green blue
3½
foxgloves, dark and light
3 ragged robins
blue green cornfield
ragged robins
green sorrel
feathery grasses – pink

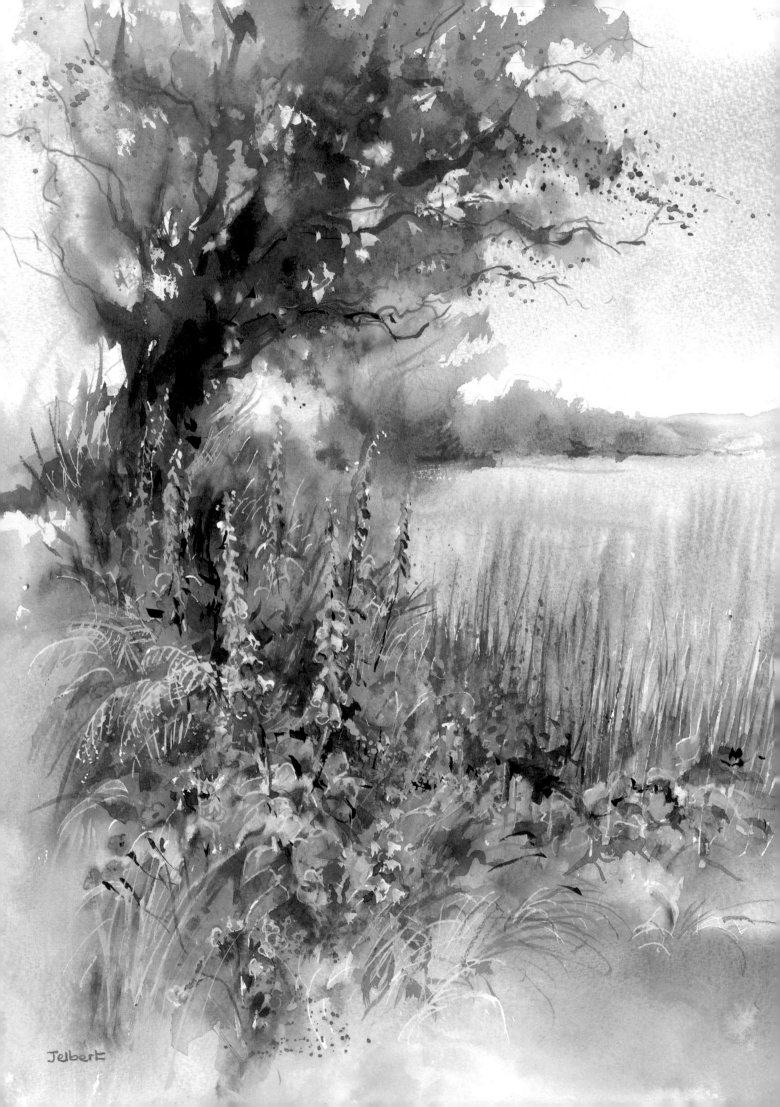

Poppies and Foxgloves

Size: 150 x 205mm (6 x 8in)

I painted this small watercolour sketch for the pure love of the flowers I picked on that day in Brittany. The colours – pink foxgloves and red poppies – should have clashed but, instead, they looked gorgeous together! The white daisies provide a complete contrast and peep out from the foliage like bright stars.

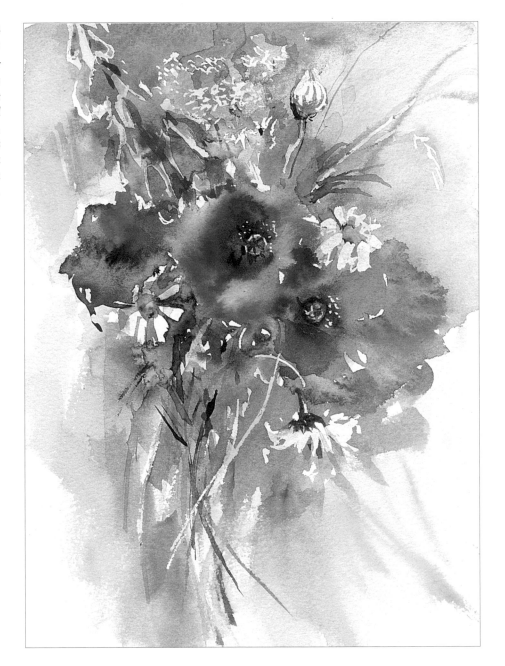

Opposite

Edge of the Cornfield

Size: 305 x 405mm (12 x 16in)

The composition of this painting includes details taken from all four of the photographs and the three sketches on pages 84–85. I had to use a magnifying glass to determine the detail for the foxgloves, but I also referred to my library of plant books. A very limited palette of olive green, yellow ochre, magenta, cerulean blue, burnt sienna and white gouache was used to paint this attractive scene.

Having made the initial drawing, I used masking fluid to save the lighter areas of the flowers and stems, and darkened several negative shapes with sepia water-soluble ink to contrast the highlights. I mixed white gouache with magenta to make opaque pinks for the very pale flower heads.

Themes

When going out on a sketching expedition, I often decide on a theme for the day. It may be garden corners, churches, tavernas, doors and windows, times of day or, as here, bridges. Having a theme makes you really look at the subject and forces you to study all aspects of it: its basic shape and structure; the details and textures; and the local environment, etc.

This small study shows how I construct bridges. The broken lines help me create the correct shape of the visible parts of the structure.

BRIDGES

Bridges fascinate me. They connect one side of a road, river or path with the other, and this link can be an important shape in a composition and could hold the focal point. An arch or span can be a beautiful feature in itself with, perhaps, a lovely reflection in the water. The angle at which a bridge is drawn or painted will also be crucial to the perspective. The materials used to build it – bricks, flints, blocks or stones – will have to be recognised and understood before you can recreate the bridge in paint.

A burnt sienna, water-soluble pencil sketch of Grange, in the Lake District, and a watercolour sketch of the same bridge, painted from a different position. The sketchbook paper was too thin to take watercolours, so I painted this on a loose sheet of watercolour paper, then glued it into the book opposite the pencil sketch.

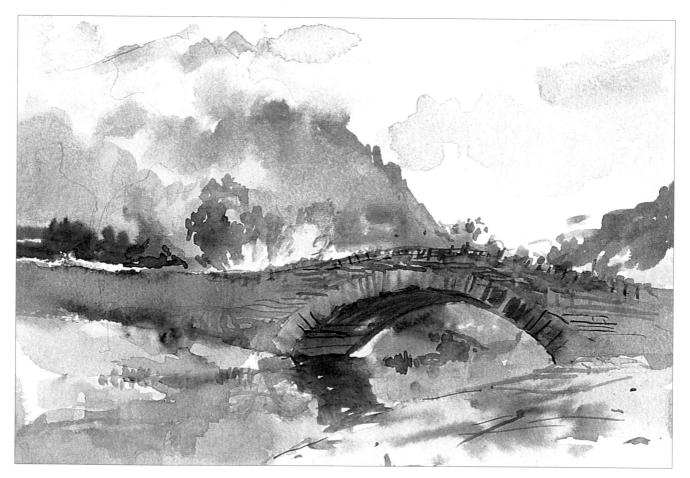

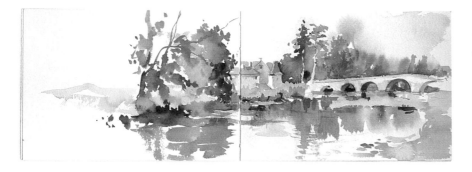

These two-page spreads from my sketchbook contain colour sketches painted in situ while on holiday in the Dordogne, France – we actually swam in this glorious river. The arches form integrating patterns in the water, and the pale reflection of the bridge contrasts with the backcloth of greenery and its reflection.

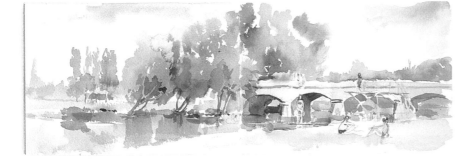

Below

This finished painting encapsulates everything I love about bridges and their reflections. The tiny vistas through the arches can often be miniature landscapes in themselves or, as in this case, provide tonal contrast to the bridge itself to draw the eye through them.

The hard reflections, painted with simple, yet forceful strokes and squiggles, add activity to the water.

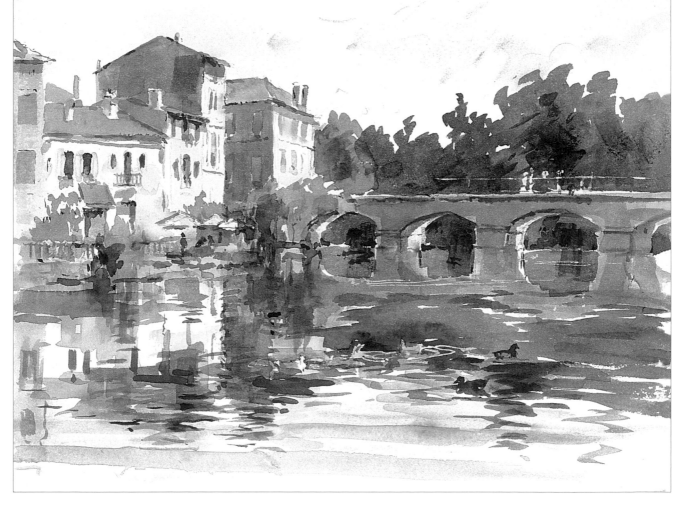

Times of the Day

These pages show what I believe a sketchbook is all about –
documenting nature in all its moods. On one of my first trips to Paxos,
in Greece, I arose very early one morning and, clutching my tiny
paintbox and small sketchbook, I went to sit cross-legged on the edge
of a cliff, to paint the scene in front of me. I then returned at various
times during the day and painted the same scene. These five sketches,
painted between 7am and 8pm, illustrate how changes in the natural
light affect the colours and mood of the scene.

 You do not have to travel abroad to experience these differences, just
look out of your window at different times of the day and you will see
what I mean. So, whether you are at home or abroad, find yourself a
scene that you are comfortable with, and paint it at intervals to capture
the changes that you see throughout the day.

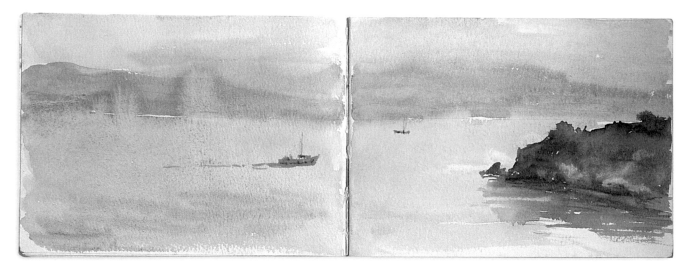

07.00: The sun was still behind the morning haze of pinks and misty blues. The headland was dark against the boiling hot sea.

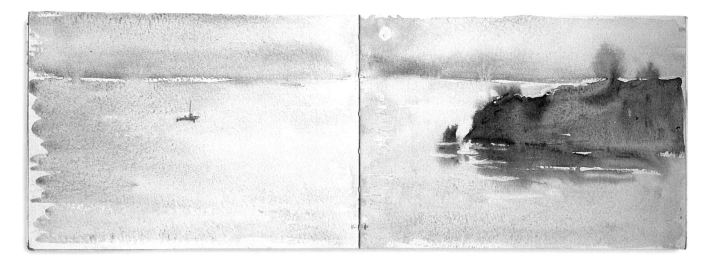

*08.00: Later on, the sun – white with potential heat – was reflecting in the sea. The headland started to get brighter and contrasted less
with the background except at its tip. The distant hills all but disappeared in the haze on the horizon.*

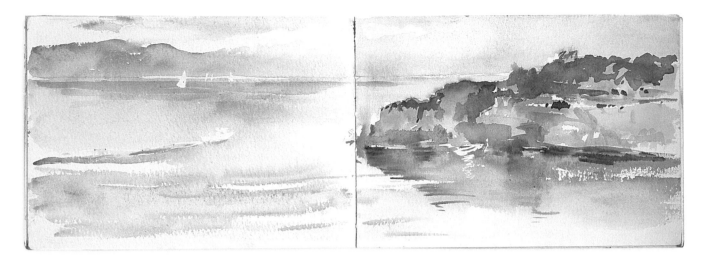

12.00: At midday the sea became more mellow and the distant mountains were covered by a heat haze which dissolved the image into a misty pink. The reflections also became more diffused, but the features on the headland became sharper and more visible.

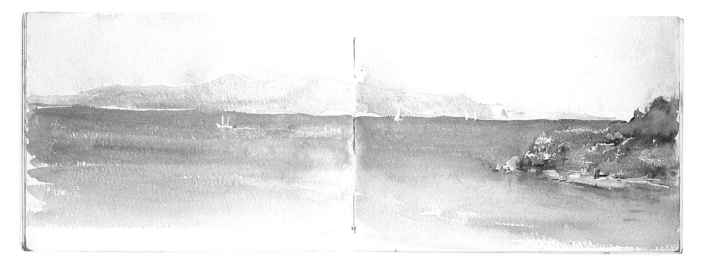

15.00: In the bright afternoon light the sea became darker and took on a vivid blue hue. The distant hills were more prominent, and the headland was lighter and brighter.

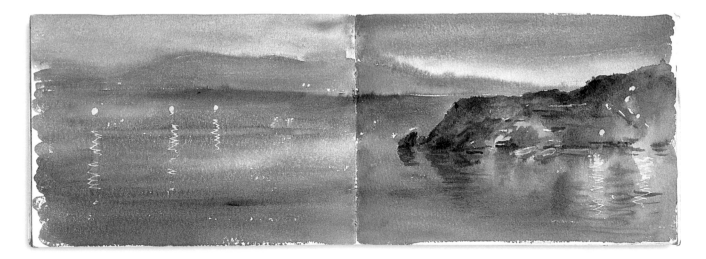

20.00: As evening faded into night Paxos twinkled with glowing lights. The headland was illuminated with yellows and whites all reflected in the dark violet-blue sea. The top edge of the headland was like a silhouette against the various lights and darks of the sky.

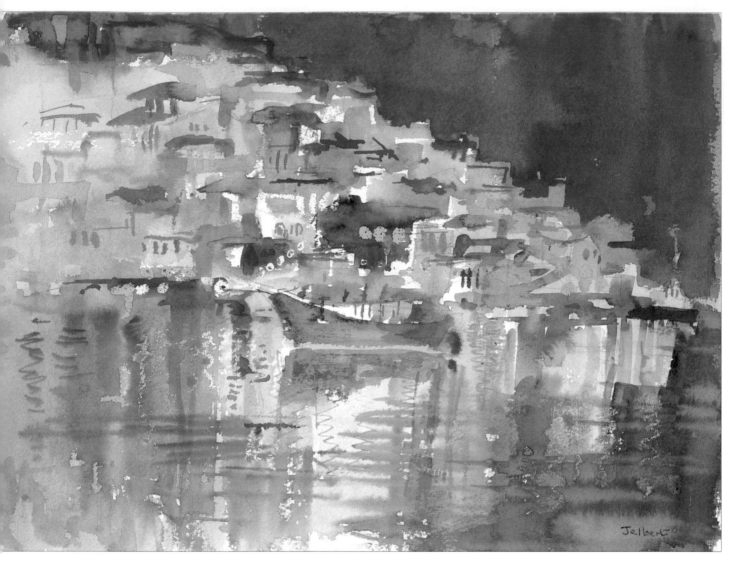

Greek Harbour at Night

Size: 365 x 275mm (14½ x 10¾in)

One of the treats I set my students when taking them to Greece, is a night scene. We try to find an ideal harbour setting so the lights are enhanced by the water. Some students will sketch the scene during the daytime to familiarise themselves with the buildings before it gets dark, whilst others turn up and hope for the best!

We spread our painting gear under lampposts or on taverna tables in the half light. Onlookers think we are crazy, whilst the local children are delighted and call us 'cool'! Several students mutter that they cannot see a thing, let alone the colours! But this is the fun element, and many do their best painting at this stage.

This is a typical Greek harbour, and we started by drawing simple shapes – the background, the sky and the sea areas. Then, working with pale oil pastels as resists, we marked the reflections of the lights on the boats and tavernas in the sea with long and expressive squiggles. Bright highlights, for the festoons of lights on the larger boats, the waterfront and surrounding buildings, were saved with dots of masking fluid. These marks allowed dramatic contrasts to be created between the dark sky and sea and the glittering yellow, red and green lights.

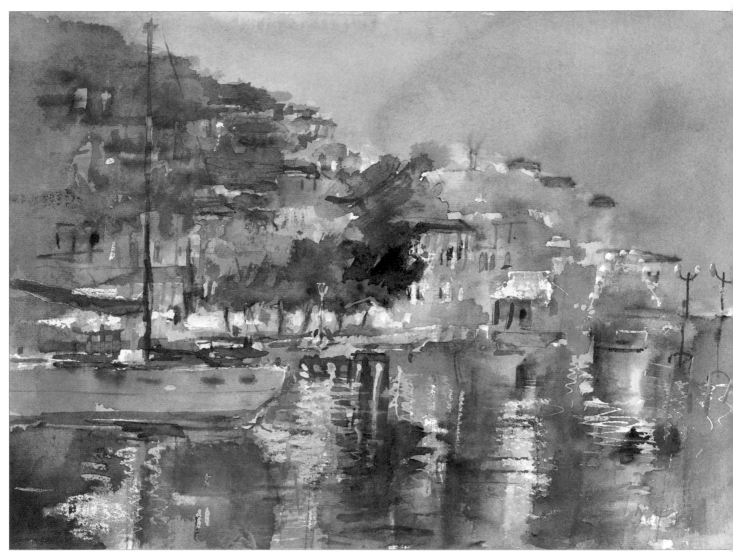

Greek Harbour at Night

Size: 365 x 275mm (14½ x 10¾in)

*I wanted to create depth in this painting of the harbour, so I placed a large boat in the
foreground to counter the background. The line of trees at the water's edge forms a lovely
dark shape which emphasizes the glittering lights from the buildings behind. These are
then echoed as reflections on the surface of the water. These contrasting and dramatic
shapes combine with the lights from the restaurant and lampposts to form exquisite
twinkling patterns – zigzag trails of pinks, yellows and creams – set against the dark blues
and violets of the sea and sky.*

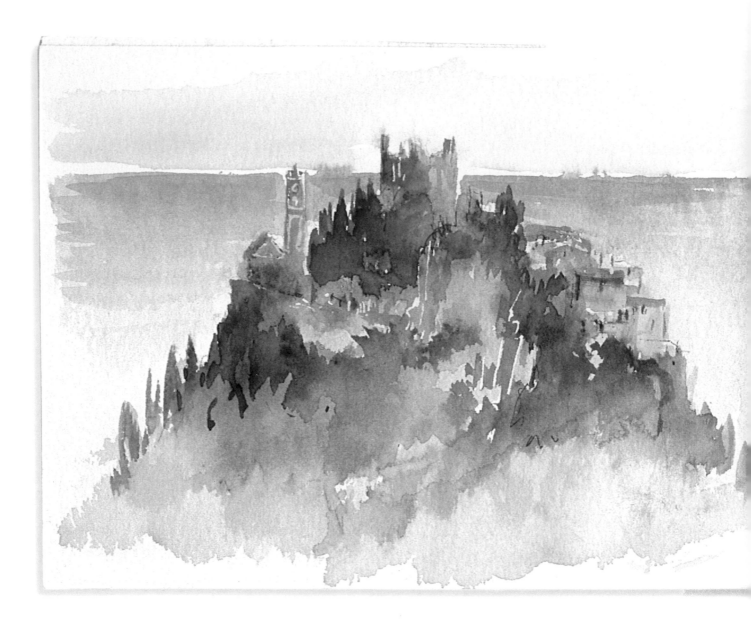

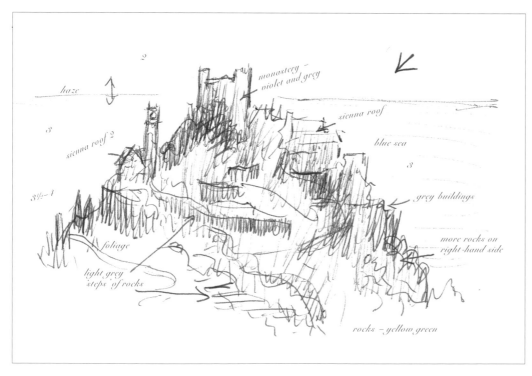

haze

2

monastery –
violet and grey

sienna roof

blue sea

3

sienna roof 2

3

grey buildings

3½–1

more rocks on
right-hand side

foliage

light grey
steps of rocks

rocks – yellow green

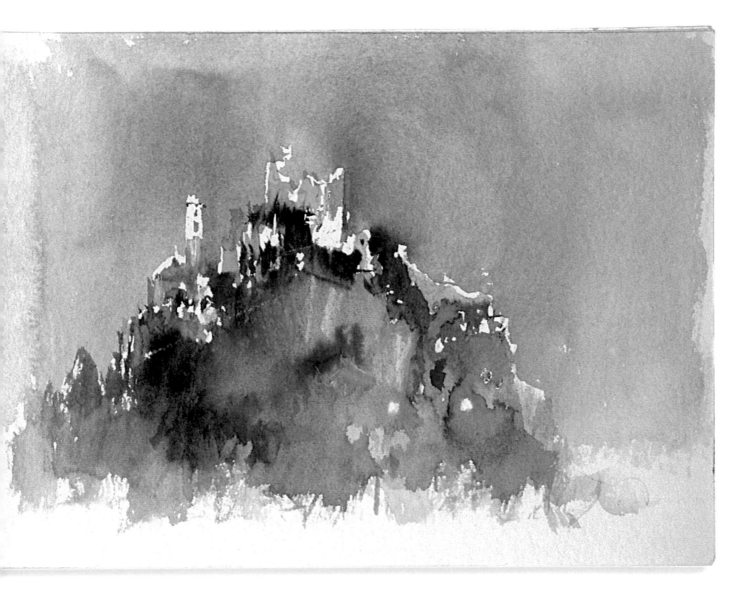

Eze, Provence, France

Elaborating on the times-of-the-day theme, I decided to try sketching and painting this wonderful medieval hilltop-town of Eze, east of Nice in Provence. On warm, balmy evenings it is so enjoyable to stroll through the town, which is bathed with twinkling street lights, and listen to the chattering crowds in the restaurants. As we wandered back to our hotel, I glanced back at the town and realised that I just had to capture the moment! I tried to memorise why I liked the scene: the contrasts; the shapes of darks and lights; and how the twinkling lamps glowed and diffused the colours about them.

Next day, when I returned to the spot, the whole scene was transformed by daylight. It was amazing to see that although the basic shapes were the same, details such as highlights were completely different. Working in situ, I sketched in the main features of the scene, then painted it in my sketchbook. Having completed this small painting (above opposite) I used a ballpoint pen to make the simple sketch (opposite) on which I added colour notes and tonal numbers. That afternoon, back in my hotel room, I used both sketches and my memory to help me paint the night scene (above).

The images in my sketchbooks do not always end up with large, finished paintings. Many of the small studies are created just for the sheer love of sketching, and I think of them as small journeys along the way. But, they always include enough information to make it possible for me to recreate the scene a year (or even ten years) later in a fresh and spontaneous way.

Index

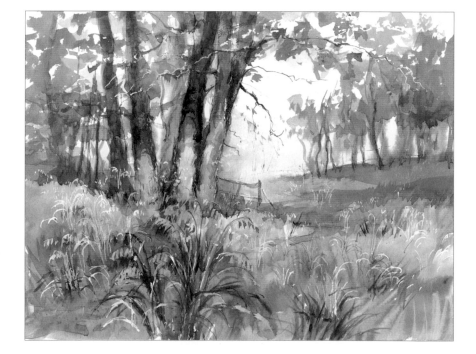

Bluebell Glade

Size: 365 x 270mm (14½ x 10½in)

This woodland scene is near Dedham Hall where I teach once a year. I always try to plan my visits so that I can sketch and paint the glorious array of bluebells.